IMAGES
of America

AKRON CHURCHES
EARLY ARCHITECTURE

On the cover: Please see page 116. (Courtesy Akron Beacon Journal.)

IMAGES
of America

AKRON CHURCHES
EARLY ARCHITECTURE

Kally Mavromatis

ARCADIA
PUBLISHING

Published by Arcadia Publishing
Charleston SC, Chicago IL, Portsmouth NH, San Francisco CA

Printed in the United States of America

Library of Congress Catalog Card Number: 2007939758

For all general information contact Arcadia Publishing at:
Telephone 843-853-2070
Fax 843-853-0044
E-mail sales@arcadiapublishing.com
For customer service and orders:
Toll-Free 1-888-313-2665

Visit us on the Internet at www.arcadiapublishing.com

For my parents, Nick G. and Regina L. Mavromatis.
I love you and miss you both so very much.

CONTENTS

ACKNOWLEDGMENTS

This book would not have been possible without the generosity of the following people; your time, help, and kindness are extremely appreciated and will not be forgotten: Howard Tolley, archivist at First Congregational Church; Pastor John G. Eiwen and office manager Kathi McGlothlin at Zion Lutheran Church; John and Carol Patterson, archivists at St. Paul Episcopal Church; Edie English, archivist at First Presbyterian Church; Fr. Joseph Kraker and office manager Eileen at St. Vincent Catholic Church; Ruth Rinehart, archivist at St. Bernard Catholic Church; Dorothy Creed, archivist at Trinity Lutheran; Nancy French, and others, at Trinity United Church of Christ; Pastor Bud Couts at Goss Memorial Church; Pastor Meaghan Froehlich at Church of Our Saviour; Paula Moran at Summit County Historical Society; Mary Plazo and Michael Elliott in special collections at Akron-Summit County Public Library; Kimberly Barth and Mark Price at the *Akron Beacon Journal*; and my mentor Mike Giannone and his wife, Jean.

Akron is surprisingly filled with a stunning array of beautiful churches. Space constraints have meant a number of these could not be included. It was not my intention to deliberately omit any one particular church, synagogue, or denomination.

INTRODUCTION

The history of Akron and its churches are inexorably intertwined with the history of the Ohio and Erie Canal. Many immigrants, initially attracted by the wages and opportunity for work during its construction, remained in Akron as the canal era gave way to Akron's emergence as a manufacturing center. As these immigrants settled here, they built churches.

Many of these early churches were modest, but as the city's fortunes grew so did its houses of worship. Just 50 years after the completion of the canal, as the *Daily Beacon* noted in 1905, Akron had become a bustling city of nearly 15,000, with "paved streets, flouring mills, mower and reaper works, foundries, potteries, paper mills, chain works, rubber works, extensive lumber yards, railroad shops, public schools, colleges, churches, streets of business establishments, private residences, etc. etc., that would be an ornament to older and larger cities."

By the beginning of the 20th century, the city's congregations had built astonishing churches and cathedrals, many of them constructed in the prevailing architectural trends of the 19th century.

Romanesque, or built "in the manner of Rome," architecture enjoyed a revival during the period from 1840 through 1900. Originating in the 11th and 12th centuries, the style was brought to America by immigrants seeking to re-create the familiar churches of Europe. Gothic architecture, which had originally evolved from Romanesque, also found favor, this time as a result of a movement seeking purity of spirit for their edifices to God. Variations of both styles were built here, each with its own unique interpretation.

The location of the vast majority of the early churches in Akron is also part of the canal story in a completely unique—and now forgotten—way.

In 1807, settler Capt. Joseph Hart, looking for a good site for his gristmill, was told of the rapids and falls of the nearby Little Cuyahoga River. Hart found the location to be more than suitable and, after building a dam, built his mill.

As other settlers arrived and began to make use of the river's power, the little town, now called Middlebury, and surrounding area grew. This influx eventually became a stampede, and by 1820, the area of Summit County was settled land.

Growth, however, uncovered a fundamental problem of geography. Getting the settlers' products and grains to market was too expensive and cumbersome. Unable to sell their surpluses quickly, they simply rotted away. Unless something was done, Ohio's economy would stagnate.

On February 4, 1825, the state legislature authorized the construction of a waterway that would connect Lake Erie to the Ohio River. The news was greeted with enthusiasm in Middlebury and throughout the rest of Ohio.

Officially called the Ohio and Erie Canal, it was more commonly referred to as the Ohio Canal. And while the Ohio legislature gave New York engineer James Geddes the mandate to use the Cuyahoga and Tuscarawas Rivers, mapping the rest of the canal route was left to Geddes.

Middlebury fought hard to bring the canal to their town. Geddes, however, noted that due to height differences in the topography the canal would be best served by following a different route, one that would bypass Middlebury completely and take it through a brand-new town.

Ten years earlier, on March 8, 1815, Gen. Simon Perkins had purchased a tract of 1,298 acres from Samuel Parkman for $2,700. As plans for the canal began to take shape, Perkins realized that his acres of land were located at a strategic point on the canal. In exchange for bringing the canal through his property, Perkins donated land for the necessary rights-of-way, thereby giving birth to the city of Akron.

Construction on the canal began in 1825, with the link between Lake Erie and Summit Lake constructed first, and later a series of 17 locks through the center of Akron.

The year 1825 was also the year New York's Erie Canal was completed. With the job finished, many of the Irish and German immigrants who had worked on "Clinton's Folly" came west to work on the Ohio Canal. They were paid 25–30¢ a day in addition to meals, a bed in one of the crude shanties built to house the workers, and a daily ration of whiskey.

As construction on the canal continued, the town of Akron gained another rival. In 1833, a fight over water rights with Middlebury forced Dr. Eliakim Crosby to plat a new community to the north and construct a race to power his mill. Perkins sold Crosby 300 acres bordered by Main and Market Streets, including Mill Street and the Little Cuyahoga Valley. Crosby intended to call this new community Cascade.

In 1832, the Cascade Mill race was completed. By 1833, the area boasted a population of 128, compared to Akron's 329. Once the plat was recorded, the name was changed to Akron, and to differentiate themselves, the two towns began to call themselves North Akron and South Akron.

As North Akron grew, a bitter rivalry sprang up between the two towns. By 1834, North Akron's population had quadrupled to 440 inhabitants, just three less than South Akron.

One thing the two towns did share, however, was a common border at Center Street. Separating the two towns was an irregular piece of land bounded by Quarry (Bowery) Street to the north and Center Street to the south; considered neutral ground, it was called "the Gore," and it was here that many of the city's first churches were built.

No discussion of churches in Akron would be complete, however, without the inclusion of "the Akron Plan," the city's unique contribution to American church architecture.

Begun as a way to provide a rudimentary education for poor children ages 6 to 12, the Sunday school movement soon sought to provide a basic education for all children and, later, for directed Bible study.

As the movement took root, the addition of Sunday school as an architectural element of churches was the brainchild of industrialist Lewis Miller. Under the theme of "separateness and togetherness," the idea was for all students in the Sunday school to be together during opening and closing exercises, but separated into their own classes for study.

Miller took his concept to renowned Akron architect Jacob Snyder. Refining it further, the Akron Plan was designed as a semicircular series of classrooms behind the congregation and above on a balcony with doors that opened and closed as needed.

The first use of the Akron Plan was in Miller's own First Methodist Episcopal Church of Akron, designed by Snyder and built between 1866 and 1867. While intended for Sunday school classrooms, the plan also became widely adopted for church construction.

The plan proved exceedingly popular, and in the late 19th and early 20th centuries, almost every Protestant and Methodist church built in the United States followed the Akron Plan.

Its heyday was short-lived, however; even though Akron Plan churches were still being built in the 1920s and 1930s, by 1905 architectural tastes changed and enthusiasm for the plan died out. As churches either added on or remodeled, Akron Plan interiors were modified beyond recognition; as a consequence, very few "pure" Akron Plan interiors remain.

One

ROMANESQUE REVIVAL

The history of St. Vincent is almost as long as the history of Akron itself.

Construction of the Ohio Canal was bringing men of adventure to Akron, including Irish Catholics who helped to dig the canal ways. Between 1825 and 1835, they were living in a series of 100 cabins in South Akron and were attended to by Rev. Thomas Martin, a Dominican father of Perry County, along with others.

In 1825, Akron formally became a city with a population of 300. St. Vincent Catholic Church was founded 12 years later, in 1837.

After worshipping in various homes, a small frame church was built on Green Street that served the parish well, but with the appointment of Rev. Matthew Scanlon in 1859, plans for a new church were put in motion and work commenced in 1864. The new church would be built in the Romanesque style, or "in the manner of Rome."

Originally developed from about AD 1000 to about the late 1100s, Romanesque Revival became a popular architectural style in the mid- to late 19th century, particularly during the period 1850–1860. It is chiefly defined by the use of stone vaulted ceilings and supporting stone piers, as stone was considered superior to the traditional—and highly flammable—wooden roofs of pre-Romanesque structures.

To support these heavy stone vaults, massive walls and piers were used to create a square or rectangular space called a bay. Enclosed by groin vaults, these were used as the basic building unit of the structure.

To make room for windows, the nave in Romanesque churches was usually higher and narrower than previously. These clerestory windows were placed in the sidewalls, below the vault. Doors and windows were usually capped with round arches, or sometimes with slightly pointed arches. These openings were generally small and decorated with moldings, carvings, and sculptures.

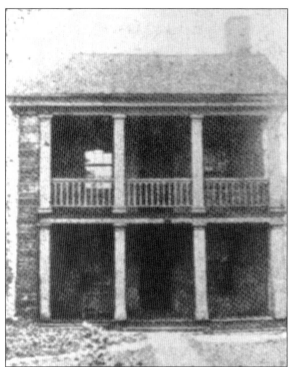

On June 19, 1821, Pope Pius VII created a new see in Cincinnati that encompassed the entire state of Ohio, with Fr. Edward Fenwick appointed bishop. Ohio continued to become organized, and in 1833, Rev. John Martin Henni came to Akron from Canton and held services in the log cabin of James McAllister. The old Dunn home, on Green Street, was also frequently used as a place of worship.

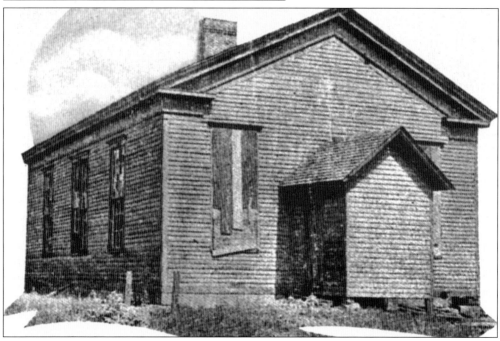

Under the leadership of Rev. Maurice Howard, in 1844 the small parish began to build its first church, a small frame structure located on Green Street on land donated by one of Akron's first citizens. Timber for the church was cut and hauled by members of the church under the direction of Howard. Later that same year, Rev. Cornelius Daly was appointed the church's first resident pastor; he would work to finish and enlarge the church begun by Howard.

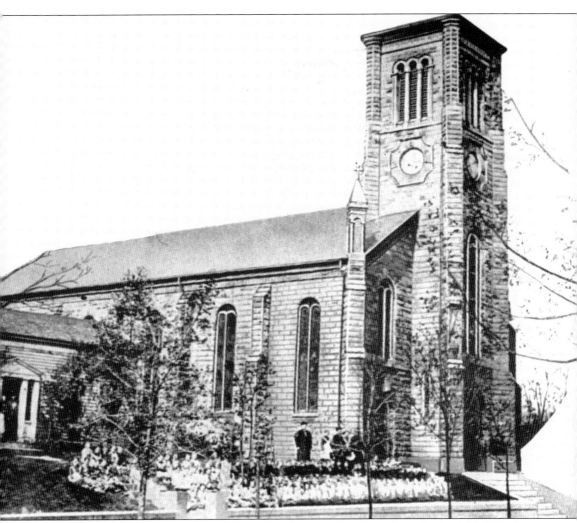

On February 18, 1864, ground was broken for the new church, and on St. Patrick's Day that same year, work began on St. Vincent's magnificent Romanesque church at the corner of West Market and Maple Streets. Under the direction of Rev. Matthew Scanlon, the massive stone structure, 50 feet wide and 100 feet long, was constructed for $50,000. Originally the church had six windows on each side, and on the keystone of each window was the head of an apostle, symbolizing the 12 foundations of the church. The church was formally dedicated on October 20, 1867. As later described by Rev. Thomas F. Mahar, "The main part of the interior is of the classic style of architecture, rather a singular case in this country, in which almost all the churches are Gothic, at least attempted. The details of ornamentation of St. Vincent de Paul's are tasteful throughout."

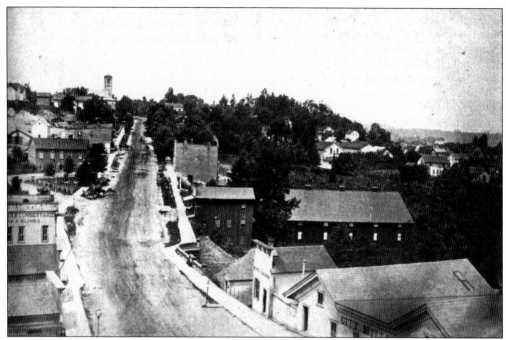

In its early days, development in Akron was primarily eastward, as the "West Hill" made transportation difficult. In this 1874 photograph of West Market Street, St. Vincent's bell tower can be seen in the upper left corner. (Courtesy Summit County Historical Society.)

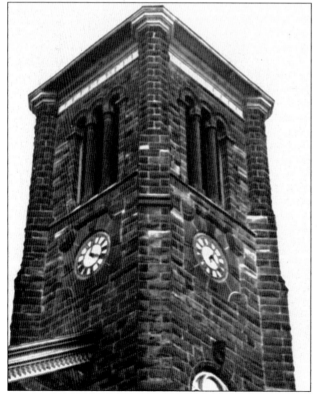

The bell of St. Vincent's tower, purchased by the congregation, was cast in Baltimore and christened Michael in 1886. The clock adorning the tower was originally installed in 1884 and was replaced in 1920. Measuring four feet seven inches in diameter, the new Seth Thomas clock was a gift of Mrs. Martin Tobin in memory of her parents, John and Catherine McGuckin.

The top photograph is the first rectory, originally built around 1830. By 1884, the rectory had become dilapidated and a new brick structure, below, costing $5,000, was built to replace it. In 1917, work began to enlarge the structure as part of the church's expansion program, and it was not completed until 1919.

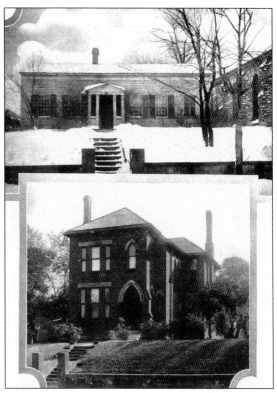

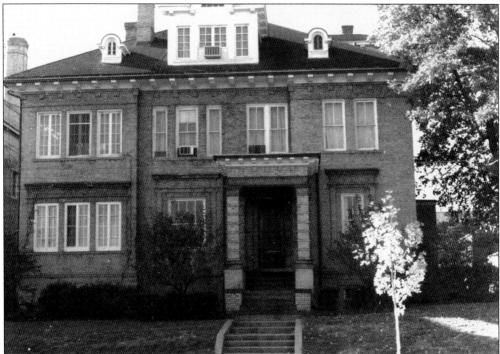

The rectory as it still looks today is seen here. It has served as the home for 15 out of the 17 pastors of St. Vincent.

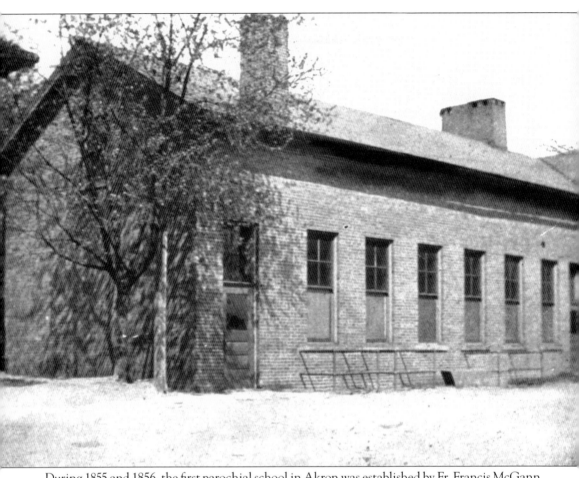

During 1855 and 1856, the first parochial school in Akron was established by Fr. Francis McGann and became known as the Green Street University. By 1881, the school was remodeled and a 56-foot-by-32-foot addition was built at a total cost of $2,000. Teaching at the school were the Sisters of the Holy Cross until 1885, the Sisters of Notre Dame until 1894, and the Sisters of St. Joseph until 1907. In 1892, the Green Street school was replaced with a new brick building at a cost of $18,000. When the Sisters of the Immaculate Heart of Mary assumed educational duty in 1907, they came with the understanding that a high school would be started, and with Rev. Thomas F. Mahar's blessing, one was quickly established. The first graduating class in 1910 consisted of four students.

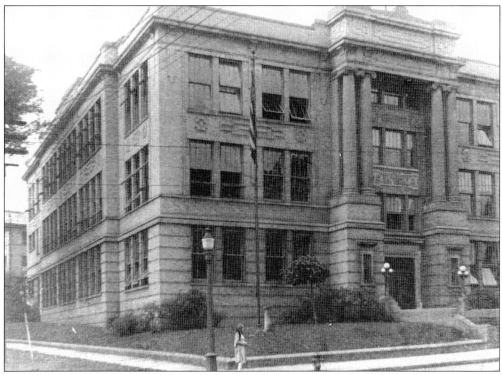

The high school students remained in one room of the grade school until 1915, when they moved into the chapel formerly in the backyard of the rectory. This served as the high school until September 19, 1919, when the students moved into this newly constructed building. In 1996, it was razed to make way for a parish family center.

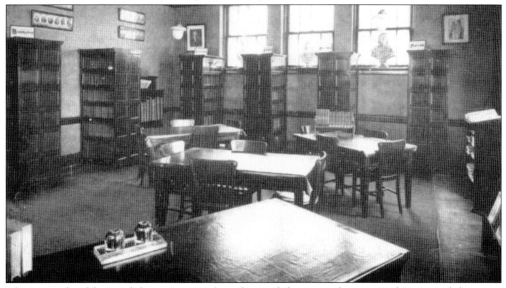

The new school boasted departments of mechanical drawing, chemistry, physics, and domestic science, all located on the first floor. The library on the second floor, pictured here, was described in the church bulletin as "a large, cozy room equipped with a high mantel and fireplace and books, mostly pertaining to school work."

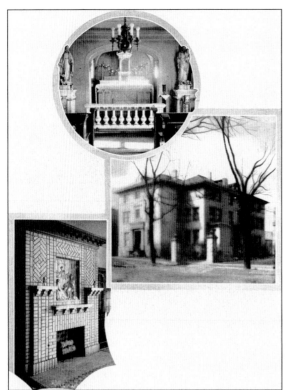

In 1888, a lot adjoining church property was bought for $3,300, and the house located on the lot, with some additions, was used as a residence for the sisters. In 1915, the church purchased additional property for $9,000 in order to build a convent for the nuns (middle photograph). Construction began in 1917, and in May the nuns moved in. They would remain there until it closed in 1981.

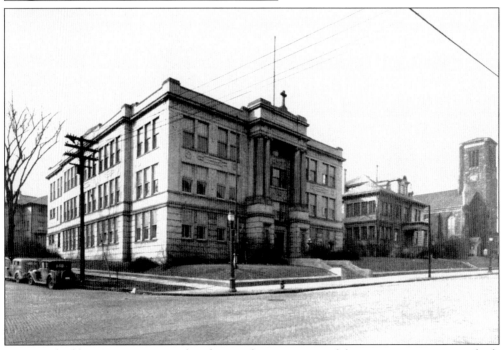

In 1917, a building program was undertaken, and construction of the new convent, rectory, high school, grammar school, and a church expansion begun. The $33,330 convent was paid for in full—not $1 was borrowed.

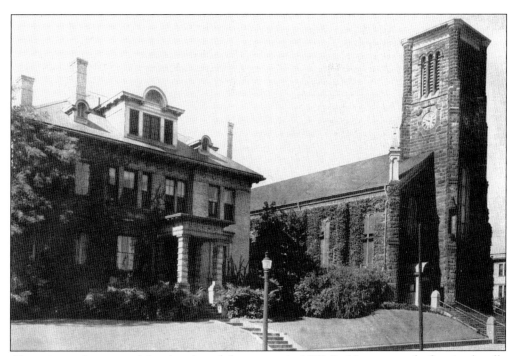

Above is another view of the church and the rectory in 1937. St. Vincent was built using locally quarried, pebbled Sharon conglomerate sandstone. Additions to the church after 1937 were made using Berea sandstone, a conglomerate that lacks pebbles and is notable for its fine horizontal stratification that is defined by small particles of reddish-brown, iron-rich cement.

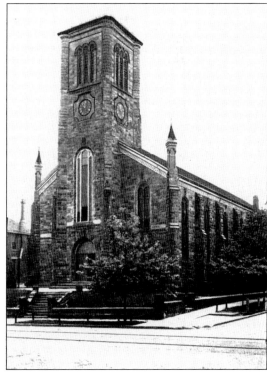

The care and maintenance of a century-old church takes constant diligence. In 1982, the church underwent several alterations, including a major renovation of the pipe organ, the tuck-pointing of the exterior walls, the installation of terrazzo floors in the church's five vestibules, the remodeling of the sanctuary, the tiling of the church floor, and the rearranging of the interior to comply with the Americans with Disabilities Act.

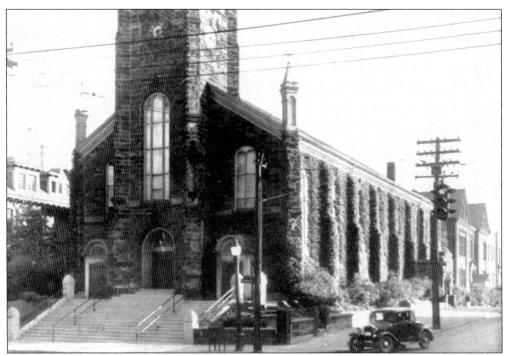

Seen here is St. Vincent in 1937 on the occasion of its 100th anniversary. Strangely enough, had it not been for World War II, St. Vincent would have been celebrating in another location. Fr. John Scullen had wanted to build a new church and had three sets of plans drawn up. In 1941, Fr. Edward Conry decided to implement those plans, but war restrictions on building materials made that impossible.

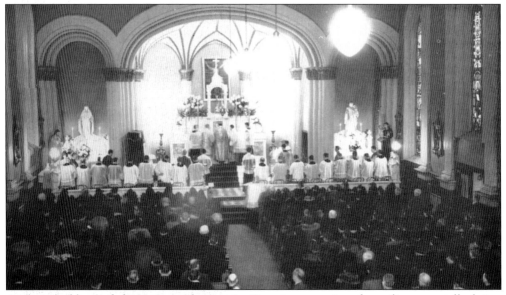

As described by *Catholic Universe*, the interior "is quite attractive, the ceiling especially, being very beautifully stuccoed. There are no pillars, and hence an unobstructed view of the whole interior. The twelve elegant stained glass windows are gifts from the different church societies and from several members of the congregation."

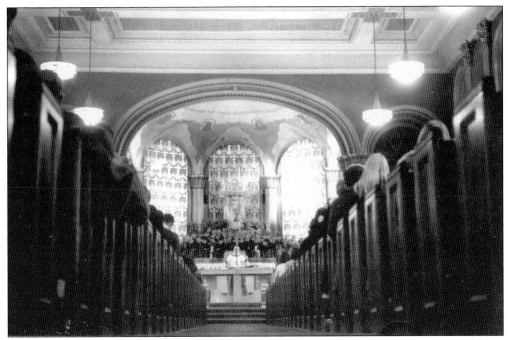

The church's altar and pulpit are made of several types of stone, including an orange breccia, red Verona marble, and Botticino marble. The Blessed Virgin altar was donated by Ellen Roche in memory of James and Margaret Roche and Mary Doyle, and the statue of St. Joseph was donated in memory of her brother William.

St. Vincent de Paul was born to a peasant family in France in 1581. After studying humanities and theology, he was ordained in 1600, and on his way to Marseille, he was taken captive by Turkish pirates and sold into slavery. After converting his owner to Christianity, he was freed in 1607. On June 16, 1737, Clement XII canonized St. Vincent, and his feast day is celebrated on September 27, the day of his death.

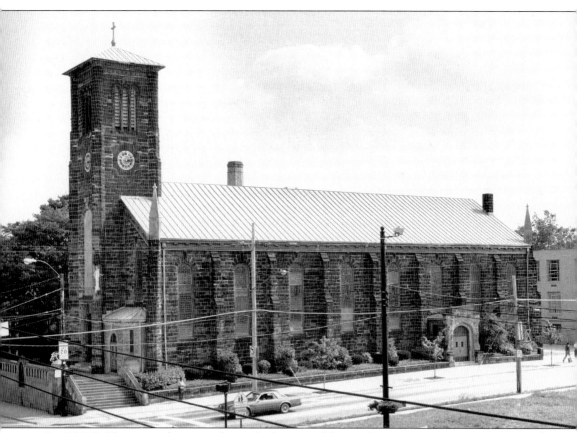

In 1997, St. Vincent underwent a thorough cleaning of the sandstone to remove over a century of soot and grime. As part of a $3.5 million renovation and construction project, the sandstone was cleaned by scrubbing it with heavy-duty detergent, then spraying it with water at 2,500 pounds per square inch of pressure. The cleaning brought forth the original bright rich beige of the stone, along with detailing that had been lost under the years' accumulations. In addition to the cleaning, the church once again replaced mortar between the stones, cleaned and repaired the tower clock, cleaned and repaired the stained-glass windows, installed air-conditioning in the church, and painted trim around the windows. The work was completed by July 27, to coincide with the Cleveland Catholic diocese's 150-year celebration.

Two

HIGH GOTHIC REVIVAL

The beginning of what is called Gothic architecture made its first appearance in medieval France during the middle of the 12th century, with the construction of the Abbey of St.-Denis in Paris.

Borrowing heavily from the Romanesque and Byzantine forms, Gothic introduced a new architectural language, which included the pointed arch, pointed rib vaults, piers with clusters of shafts, deep buttresses (some of the flying type), window tracery, pinnacles, spires, battlements, and a sense of height.

The development of the style can be subdivided into three periods: early (13th century), characterized by lancet windows without tracery; decorated Gothic (about 1290–1350), in which windows have first geometrical, then flowing, tracery; and perpendicular (about 1350–1530), with its heavy use of vertical lines.

The style lasted until the 16th century, when it was replaced by the classical forms of the Renaissance. However, it continued to be used for churches and cathedrals already in progress as well as in more isolated and rural areas.

Gothic architecture enjoyed a rebirth in popularity during the early 18th and much of the 19th centuries. As industrialization spread throughout the Western world, a yearning for simpler times led many to associate the earlier Gothic edifices with the seemingly more simple spiritual piety of the medieval era. Among the educated classes a renewed interest in medieval history helped fuel its growth, as did a growing literary movement rooted in Romanticism, with its emphasis on trepidation, horror, and the awe experienced in the face of nature, giving rise to the Gothic novels of the era.

However, sentiment on the employment of Gothic elements is split, with the ecclesiological movement declaring that only churches conforming to the classic style in exact detail could be considered "true," while others sought merely to either use elements of its design or combine it with other styles.

The use of Gothic as a design template has never really faded. Despite being replaced by a move toward modernism in the early 20th century, heavily Gothic-inspired buildings continued to be built well into the 1930s. Even into the 21st century, buildings are being constructed that draw on the detailing and tracery of this enduring style.

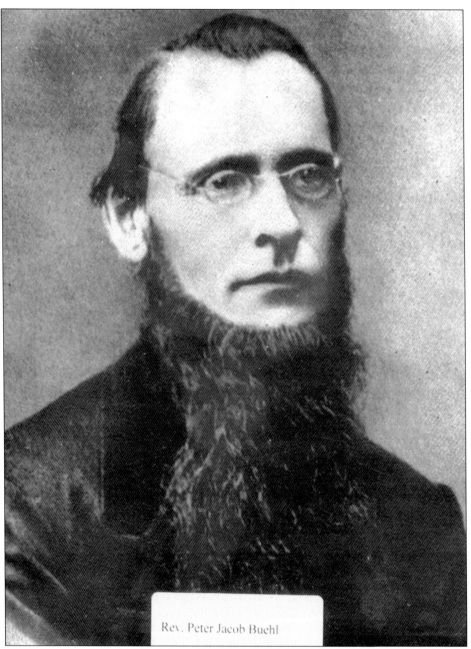

Rev. Peter Jacob Buehl

The construction of the Ohio and Erie Canal brought many immigrants to Akron in the 1820s. In 1854, a young pastor by the name of Peter J. Buehl came to minister to the Germans who had come to work on the canal and settled here. Buehl, born in 1827 in Germany, arrived in America in 1849. A graduate of Massillon High School, he founded mission congregations in Canal Fulton, Wooster, Orrville, and Clinton before locating in Akron. During this time, a small group of Lutherans was worshipping along with members of the German Reformed Church, with the group calling itself the German Evangelical Protestant Congregation. On August 6, 1854, Buehl organized 15 families into a congregation, and in 1858, Zion Evangelical Lutheran Church was registered and incorporated at the Summit County Courthouse.

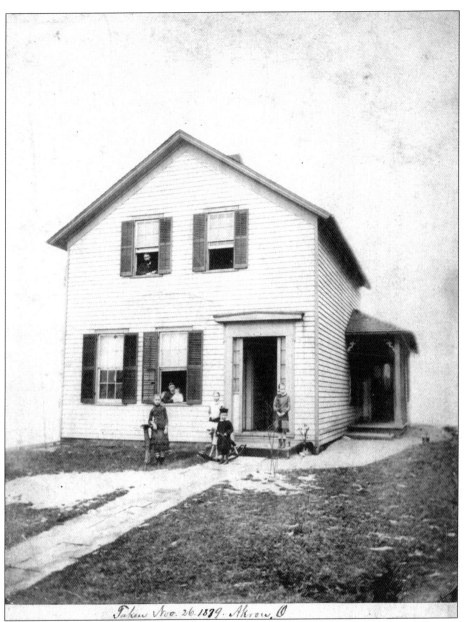

Taken Nov. 26. 1879. Akron, O

After formally organizing the small church, in 1855 Buehl and the congregation of 75 members purchased a lot and small house from the Disciples of Christ on the corner of South High and Quarry (now Bowery) Streets for $1,000. The hand-hewed beam and clapboard-sided Greek Revival house had been built by the First Congregational Church and was originally located on South High Street; in 1840, Gen. Simon Perkins, Akron's founder, moved it at his expense to make way for the new courthouse. In 1864, Buehl decided to return to Massillon and was replaced by Pastor G. Theodore Gotsch. Continued growth of the congregation prompted the construction of a new parsonage; the lot to the north was purchased for $300 and Zion's first parsonage, pictured here, erected. The two-story rectangular building, with a wood shingle roof, three bay-side hallway entrances, side-entrance porch, and one-story hipped roof addition on the back was built at a cost of $700.

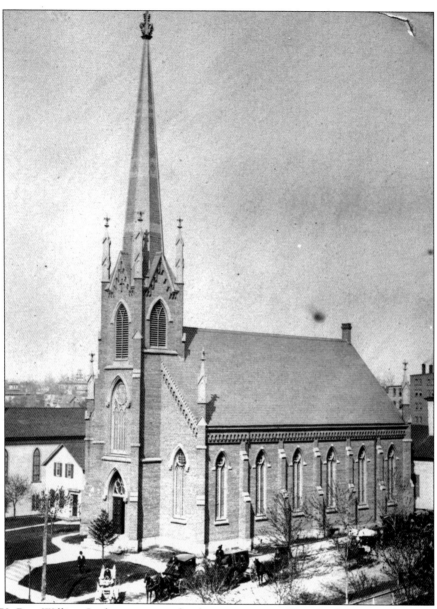

In 1872, Rev. William Lothmann arrived to become pastor of Zion Lutheran. With membership rapidly increasing, the congregation quickly outgrew the small Greek Revival building and decided to build a new church. Thanks to the financial assistance of Akron businessman Ferdinand Schumacher, the "Oatmeal King of America," this High Gothic Revival church was constructed at a cost of $16,000. To help keep costs down, many in the congregation were involved in building the church. Built of soft red brick, the 50-by-100-foot church is basilica style, or rectangular in shape, consisting of narthex, sanctuary, and chancel. Brick buttresses divide the church into six bays, while pressed metal pinnacles at the four corners of the church and tower continue the Gothic features. In contrast to the dark brick, light-colored sandstone trim and accents add visual interest. In this 1879 photograph, the parsonage can be seen to the immediate left of the church, while the Greek Revival original church, used as a school, is at the right behind the church. The unusual top to the spire was later replaced with a cross.

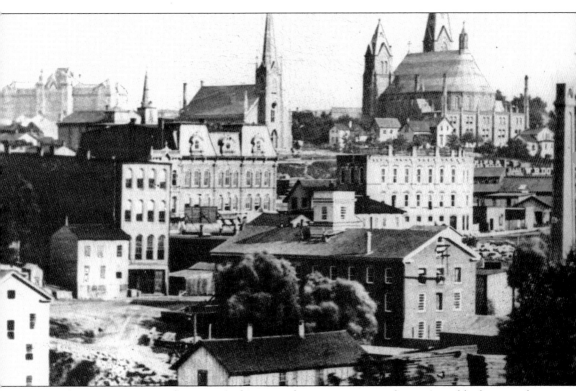

As early as 1879, Zion Lutheran's 150-foot spire became an instantly recognizable feature of Akron's skyline. When the church was dedicated on September 16, 1879, the *Summit County Beacon* called the ceremony "a demonstration of unusual impressiveness." The article went on to praise the building: "It is sufficient to say, however, that in beauty of outline, harmony of detail and richness of decoration it is surpassed by no church of in [*sic*] the city and by very few of the size in the State." Going on to praise the "handsome and commodious" building, the newspaper observed that for the occasion while only 100 persons from both Cleveland and Massillon were expected to attend, instead 398 passengers arrived from Massillon and 450 from Cleveland, including a brass band. At 9:30 a.m., the attendees gathered in the old church and heard a sermon preached in German by Rev. Peter J. Buehl. Afterward the crowd of 1,200 to 1,500 followed Rev. William Lothmann to the new church where he blessed the doors, saying, "In the name of the Father, Son and Holy Ghost, I open this church."

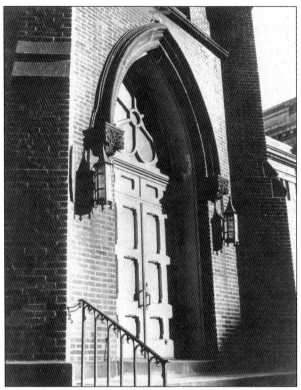

The pointed arch over the front doors is typical of Gothic Revival, while above the doorway resting on carved stone corbels are pointed stone hoodmolds. Originally a feature of Romanesque architecture, these were used to divert rainwater away from the opening and eventually became a feature of Gothic architecture as well.

Closer inspection of the front reveals the beauty of the church's stained-glass windows. A rose window decorates the transom above the double-door entry, while at the sides double-lancet windows with quatrefoil (four overlapping circles) tracery at the top complete the facade.

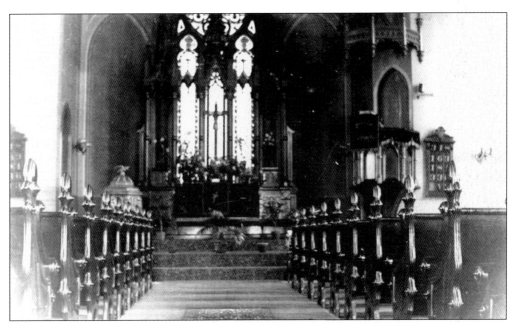

At the time of its completion in 1877, the sanctuary was described by the newspaper *Germania*: "Even though it is not richly furnished, it is the most beautiful and tasteful church of our city, not only on the outside but also in the inside." Its ceilings were decorated with frescoes by William Beck. In 1904, extensive repairs and renovations were made, with the *Summit Daily Beacon* reporting that "the inside of the edifice has been thoroughly remodeled and refreshed."

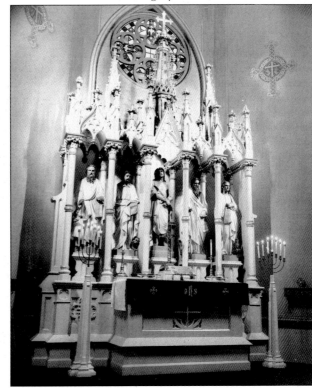

The altar of Zion Lutheran is similar to the altar at Trinity Lutheran. Both feature the figure of Christ in the center, Matthew, on the far left, next is Mark, then Luke, and John at the far right.

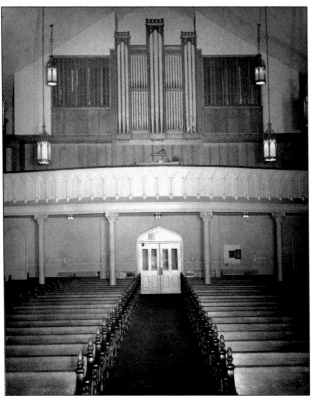

Looking toward the front of the church from the chancel, pictured at top is the organ; the original was pumped by hand until later, when it was run using waterpower. In 1858, Pastor Peter J. Buehl lent the congregation his organ, and the church's first organist on record was a Mr. Martin. The organ was later refurbished in 1987.

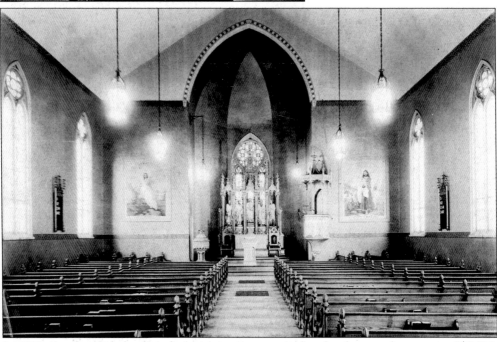

In 1928, the church, school, and parsonage were repaired and redecorated at a cost of $7,000. This time, the sanctuary and chancel were given a more High Victorian Gothic look, using a much more elaborate and eclectic style than before.

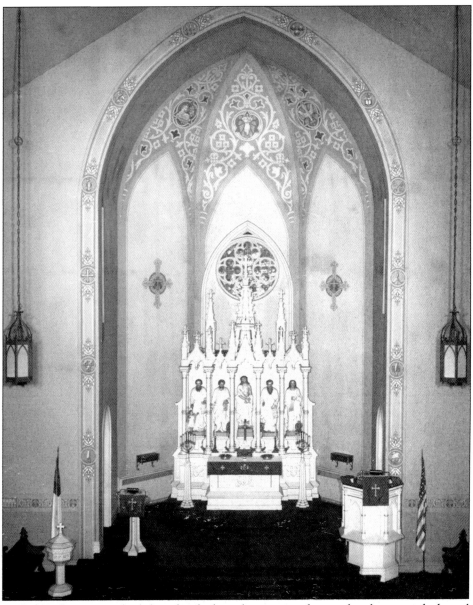

By 1954, the frescoes to the left and right have been painted over, the altar moved, the pulpit lowered, the lancet windows covered, the reredos closed from the back, and the hood overhead removed. Added to the highest point of the altar niche are paintings representing the three symbols of the Trinity. On the left is Agnus Dei, or the lamb of God with the banner of victory; the center, a hand pointing upward symbolizing the hand of God; and on the right a dove representing the Holy Ghost. On the chancel arch are the representations of the 12 apostles; starting on the bottom left is a saw for St. James the less; money bags for St. Matthew, the former tax collector; a cross/spear for Philip; a cup and coiled serpent representing St. John; a shield with two fish for fisherman St. Andrew; three knives for the sacrifice of St. Bartholomew; scallops for St. James the elder; a Bible and fish for St. Simon; crossed keys for St. Peter; a carpenter's square and spear for St. Thomas; a Bible and halberd for St. Matthias; and a sailing vessel to represent St. Jude.

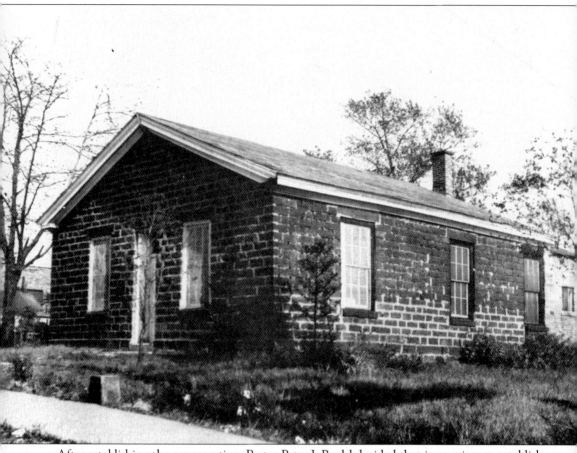

After establishing the congregation, Pastor Peter J. Buehl decided that it was time to establish a school. Classes were first held in the pastor's own home, but as attendance grew, he moved the students to the city's first public school building at the corner of Broadway and Middlebury (now East Buchtel Avenue) Streets. Built in 1840, "the Old Stone School" was Akron's first public school building, but at the time of Zion's occupancy, it was a small frame building; not until 1867 would the city rebuild it in stone. However, the Zion school's continued enrollment necessitated the construction of its own building, and in 1863, the 20-foot-by-26-foot clapboard "yellow schoolhouse" opened. But growth remained steady, and during the building of the new church, the original Greek Revival church was moved to the lot in the back and classes held there. Eventually even this proved insufficient, and in 1889, the congregation began construction on yet another school.

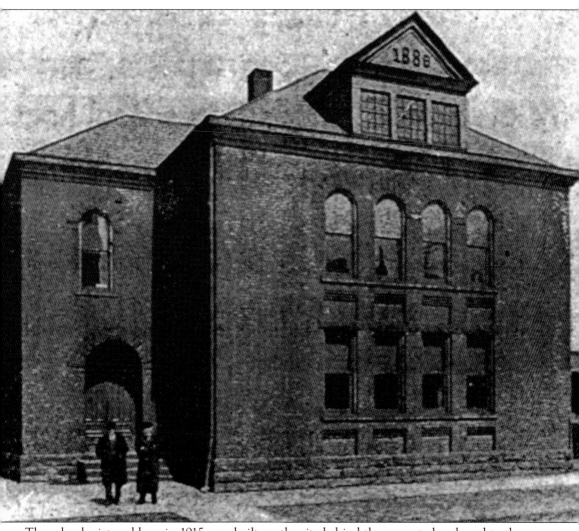

The school, pictured here in 1915, was built on the site behind the present church and to the east on Quarry Street. After 54 years of continuous service for church and school purposes, the original Greek Revival church was razed. During construction of the new school, students were given three months' vacation. The cost of the new church, according to the *Summit County Beacon*, was estimated to be $6,000 or $7,000. The Lutherans, the *Beacon* pointed out, who placed an emphasis on scholarship, continued to pay the new tax system established by the Akron Board of Education. "But while the German Lutherans prefer to educate their children in their own school, and at their own expense, they do not wish to be relieved from the common school tax, rather regarding that as a duty owned to the poor children who would get no education." The new school was built in the Romanesque Revival style, with Richardsonian Romanesque touches, particularly notable in the window arches.

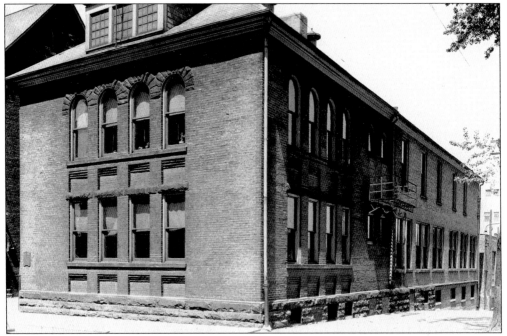

In 1915, a $12,000 addition was built onto the school, featuring an auditorium with stage, another classroom, a kitchen, a library room, and bowling alleys in the basement. In 1954, the growing school added yet another building to its complex, a three-story redbrick educational-recreational building that provided a gymnasium, concert hall, additional classrooms, and offices.

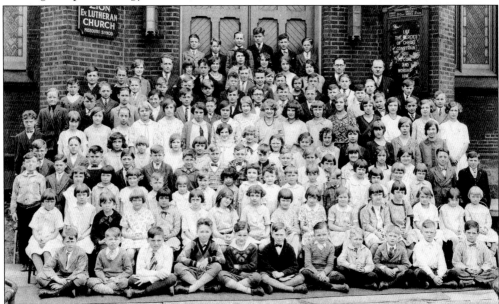

By 1954, enrollment had doubled from 136 students nine years previously to 260, and the kindergarten expanded to three days a week year-round. The school's location in downtown Akron left it landlocked, so recesses were held on the playground roof of the new addition. In 2003, despite a 140-year tradition, declining enrollment and rising costs forced the school to close on June 7.

In 1901, the church built a new parsonage at a cost of $5,100. As described by restoration architects Chambers, Murphy and Burge in the preservation master plan for the church, the new brick parsonage (rectory), built to the north of the church, "was a two-story Colonial Revival structure with a full front porch, and partial rear and side porches. It had four dormers on the hipped roof, typical of the American Four Square home type." In 1945, a new home for the pastor and his family was purchased on Moreley Avenue for $13,500, and the school constructed a new building on the site of the old parsonage. Completed in 1954, the new educational-recreational building, a concrete and steel structure with brick veneer and stone detailing and trim, was built. It featured the inclusion of a Gothic porch, a copy of one removed from the church during the 50th anniversary renovations in 1904, giving it some harmony with the surrounding older structures.

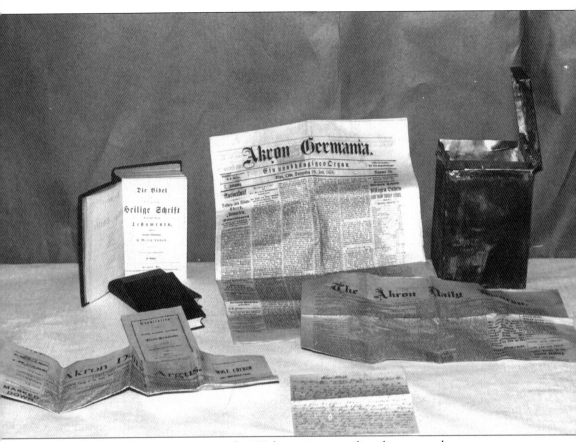

On May 23, 1976, to commemorate the 100th anniversary of its placement, the cornerstone was opened up and the contents revealed. Inside the time capsule were four newspapers, the *Akron Daily Argus*, the *Akron Daily Beacon*, the *Akron Germania*, and the German-language newspaper *Die Abendschule*; an American calendar for German Lutherans; a German Bible; a German hymnal; a copy of the church constitution; a copy of Martin Luther's *Small Catechism*; a letter from Dr. William Lothmann; and an assortment of calling and business cards from members of the congregation. In 1876, Akron had a population of 16,000, newspapers cost 3¢ each, Custer's annihilation at Little Big Horn was national news, and Ohio governor Rutherford B. Hayes was campaigning for president.

In 1954, the cross atop the church's tower was removed for cleaning and repair. Formerly covered in bronze paint, this time the cross would be covered in gold leaf. Church deacon Ronald Arkwright, a steeplejack for a local paint company, went to the top of the steeple and brought the cross down for its restoration.

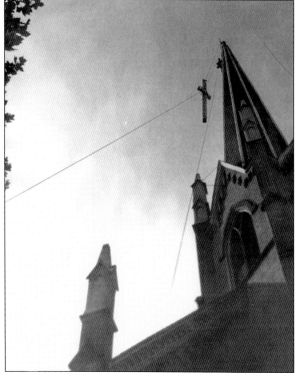

According to an article in the *Akron Beacon Journal*, "Only once in all its 78 years had the cross been removed from its perch. That was so long ago neither the pastor nor most of his congregation can remember just when it was taken down for painting."

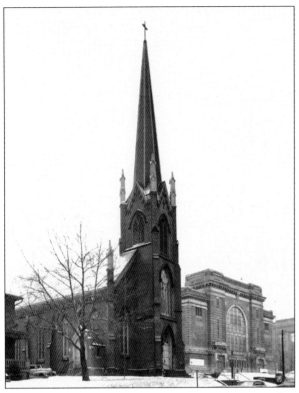

Zion Lutheran is seen in the early 1950s. To the right is the old Akron Armory, torn down in 1982, and to the right of that the Summit County Courthouse. A corner of the 1901 parsonage can be seen to the left. Little changed since its original construction in 1877; for over 150 years, Zion Lutheran Church has been a central part of Akron's landscape.

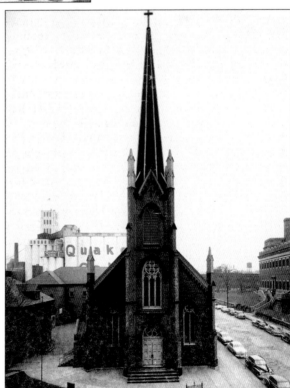

Pictured here is another view of Zion Lutheran, this time with a view of the Quaker Oats silos in the back.

Two

LATE GOTHIC REVIVAL, FRENCH PERPENDICULAR

"As soon as we step in the door, the very air that we breath is suffused with dignity and repose and grace . . . every line is the rule in the purest Gothic, is one of aspiration. Instinctively it elevates the thought above. This church, the direct heir to Luther's religious heritage, strives to maintain a balance between the intellectual and the emotional approach to religion." In his speech on the 25th anniversary of the dedication of its sanctuary, Dr. Franklin Clark Fry captured the very essence of Trinity Lutheran Church—and of French perpendicular architecture.

Perpendicular Gothic is characterized by an extreme sense of verticality: straight lines rising from the ground, seeming to reach for the sky, reaching toward the heavens. It was meant to be the ultimate expression of exaltation, a feeling of upward movement toward God.

The Perpendicular Gothic period (or simply perpendicular) is the third historical division of Gothic architecture. It began to emerge in the middle of the 14th century and rose out of the decorated style. Also called rectilinear, or Late Gothic, it lasted into the mid-16th century.

This new expression of architecture would not have been possible in Romanesque. Where Romanesque depended upon heavy walls and massive piers to support vaults, the verticality of perpendicular was achieved by a new mastery of the pointed arch. Able to be varied to almost any degree, vaults could now be used with greater flexibility. The weight supported by pointed arches or ribs could be concentrated at particular points and transferred to the ground using flying buttresses placed outside the building. Instead of depending on load-bearing walls, buildings now relied on a balance of forces, allowing walls and ceilings to soar to new heights.

It was this new mathematically based precision in the construction of churches that gave Gothic almost mystical reverence during its revival period. Enormous energy was devoted to contriving exact geometric means of creating in stone what architects and their patrons projected as the order and majesty of God. A Gothic church was intended to represent the mathematical perfection of the Creation.

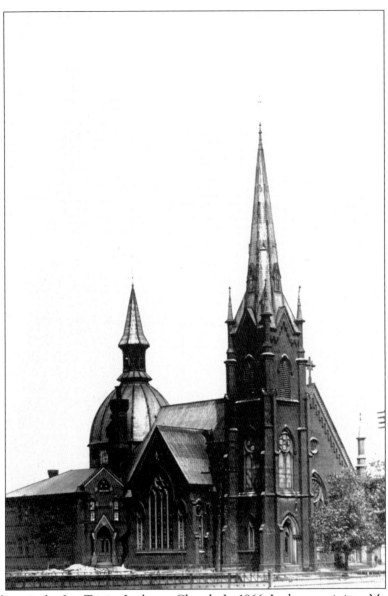

Pictured above is the first Trinity Lutheran Church. In 1866, Lutheran minister Morris Officer came to Akron looking to establish a Lutheran church in the flourishing city. At the time, J. F. Seiberling and his family were worshipping at the Congregational church. However, after conversations with Officer, Seiberling called together other Lutherans who also met with Officer, listening to his sermons and receiving communion. After a short time, Officer left Akron, leaving a void that would not be filled until 1868 with the arrival of Rev. Dr. William Pasavant of Pittsburgh. Under his encouragement and the subsequent guidance of Rev. W. P. Ruthrouff, the fledgling community began regular Sunday worship services. On June 21, 1869, the church was formally organized, and charter members J. F. Seiberling, J. H. Hower, and Charles Miller purchased a lot on South Prospect and Mill Streets for $10,000 in anticipation of building a church. After receiving $40,000 in subscriptions for the new building, the design of the new church and the erection of the main part of the building was awarded to the architectural firm of Griese and Weyle of Cleveland on April 19, 1871.

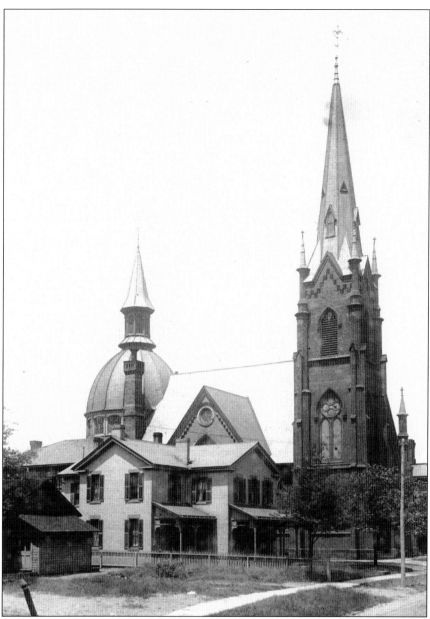

By the time of its dedication in May 1872, the entire $45,000 cost of the church had been raised, leaving the church debt free. In 1882, it was decided that a chapel was needed, along with remodeling the interior and adding a tower to the present church building and starting a Sunday school. Once the church was ready, the congregation moved in the first week of March 1883. In the 100th anniversary publication *Heritage*, Dr. Harry W. Hanshue recalls the old building: "Old Trinity on the hill, her tall and imposing spire dominated the community. . . . Though the sanctuary did not have Lutheran appointments, still it was churchly and impressive with its rich walnut chancel and pews, its tall stained-glass windows and soft carpets. It used to thrill me to watch the janitor on Sunday nights light the ring of gas-jets on the big chandelier, which was accomplished by means of an alcohol torch on the end of a long bamboo pole." (Courtesy Akron-Summit County Public Library.)

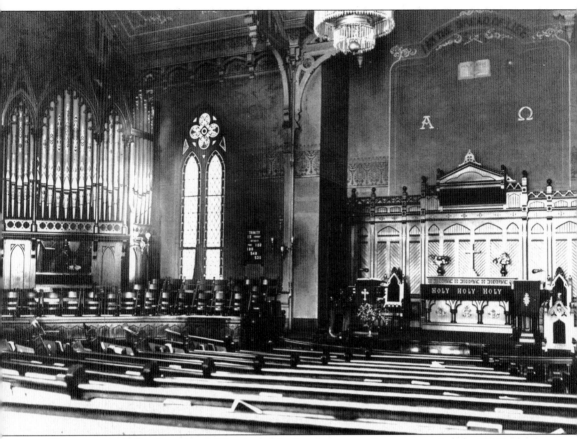

The interior of the first church lies in marked contrast to the present church. While both churches were constructed in the Gothic Revival style, here the design is characteristic of the English High Victorian movement, popular from 1850 to 1870. In fact, the church itself was built from brick, which, while not characteristic of traditional Gothic architecture, grew in use and became a major part of High Victorian design. Unlike the extreme verticality of later Gothic Revival and the present Trinity Lutheran, here the tone is softer, more graceful in nature. High Victorian emphasized rich materials and colors, reflected in stained-glass windows, intricate metal work, colored tiles for walls and floors, and beautifully carved woods. The construction and design of a church like this, one that combined Gothic sensibilities with touches of late medieval Italian and French decoration, would have been considered abhorrent to the adherents of the theologically and architecturally correct Ecclesiological Society.

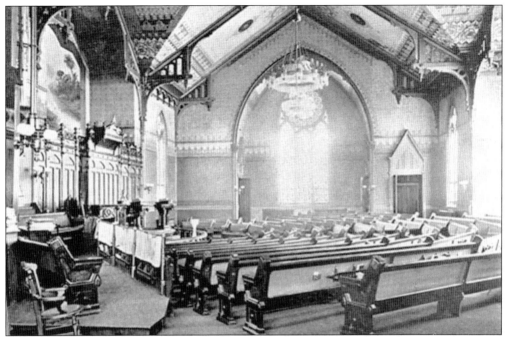

Seen here is the interior of the first church around 1896. The King's Daughters was responsible for taking care of the altar and distributing flowers to the sick. The group disbanded in 1904 and was replaced by the Altar Guild, which took care of the new altar purchased by the Luther League, along with the baptismal font and choir vestments.

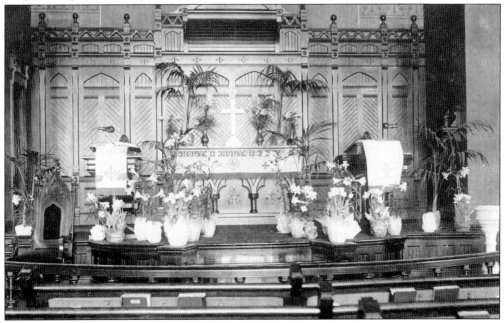

Easter is being celebrated here in the old church. According to *Heritage*, the church was plagued by problems big and little, including "repairing the parsonage stable, procuring a shade for the pulpit lamp and sash cords for the windows in the Sunday School, and eliminating a draft from the organ which made the choir uncomfortable."

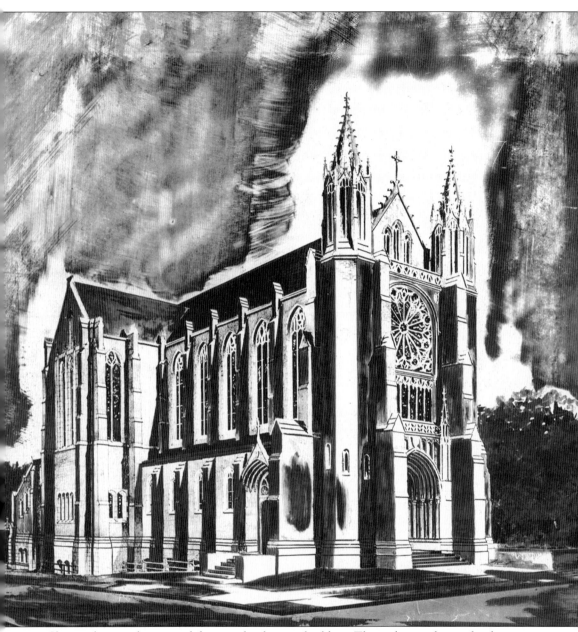

Shown above is the original drawing for the new building. The architect chosen for the project was John W. C. Corbusier of Cleveland. A national authority on church architecture, Corbusier designed other Gothic-influenced churches in Cleveland and throughout the Midwest. His dedication to the style was a reflection of the prevailing sentiment of the time; during the 19th century, Gothic architecture had become associated with the "Age of Faith," or a time when it was believed Christianity was at its purest and strongest. Looking to adapt this sentiment to the modern age, Corbusier saw an opportunity with Trinity Lutheran to demonstrate the feasibility of building a small church edifice adapted to current standards that, according to *The Architectural Record*, possessed "the dignity and churchly feeling peculiar to the great Gothic structures of the past."

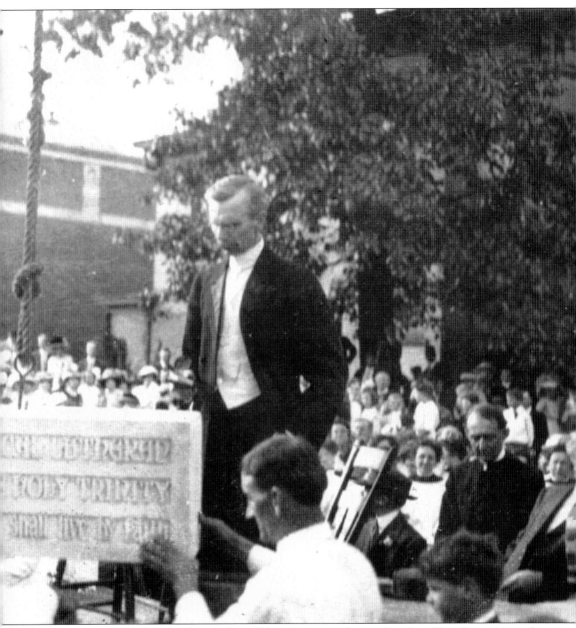

No sooner had the church celebrated its 40th anniversary than it found itself in the position of becoming flanked by the Cleveland, Akron, and Cincinnati Railway Company. Indeed, while excavating for its switching yards, the railway came so close to the parsonage that workmen had to drive huge piles to keep the gray brick house from falling into the hole below. In preparation for the new church, a parcel of land at the corner of Park and Prospect Streets was purchased on November 29, 1911; ground was broken nearly a year later on November 17, 1912, and the cornerstone laid on June 22, 1913. During construction, the congregation continued to use the church rent free for one year, as provided by the terms of the sales agreement. Upon its completion, the old church was torn down and the lot sold to the railway company for $75,000.

TRINITY
ENGLISH LUTHERAN CHURCH,
ERECTED A.D. 1871,
REMODELED AND CHAPEL BUILT
A.D. 1883.

The cornerstone of the first church was laid on June 4, 1871, with approximately 400 people present. Once the church was torn down, the cornerstone was brought to the new building and set into a narthex wall. It contains a time capsule whose contents were examined when the church was razed.

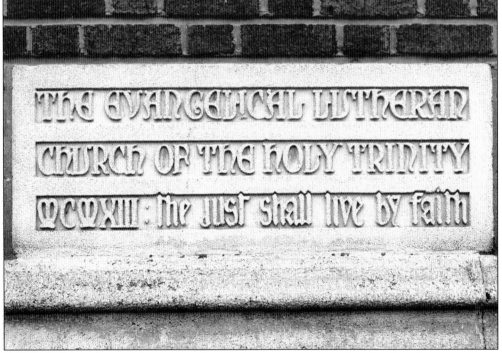

This is the cornerstone of the present church. A time capsule is enclosed within this cornerstone as well, containing a Bible, book of worship, memorials of the 25th and 40th anniversaries of the church, a New Testament published in 1828, six church periodicals, copies of Akron newspapers, complete rolls of Sunday school and church members, pictures of the old church, and a number of small articles.

Evangelical Lutheran Church of the Holy Trinity still looks today as it was built in 1914. Like the first church, this was also built in the Gothic style. For its December 13, 1914, dedication, the church published a program that went into elaborate detail describing the building's array of impressive details: "The front of the building conveys a distinct impression of both massiveness and delicacy. The great buttresses which flank the doorway melt upward into the twin towers, and produce a fine sense of unity and stability. Their dark brickwork is softened by contrast with the light stone trimmings; and they frame in, like a picture, the grouping of portal and rose window, for whose lace-like detail they form an excellent foil." In 1987, the church underwent an extensive $700,000 historic renovation. The project included a thorough cleaning of the church exterior and new offices. Towers that had been leaking water were replaced, and a pair of tall Gothic steeples were re-created in fiberglass to replace the church's long-lost originals.

Topping the church are two Late Gothic Revival spires. As the dedication program notes, "Crowning all, and pulling the composition together, the rich, light detail of turrets and gable lends an air of exquisite delicacy to the whole."

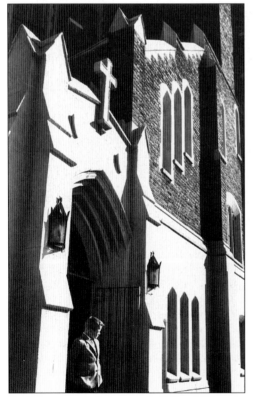

The brick used to build the church is dark and irregular in color and rough in texture. It was selected specifically for these characteristics in order to closely mimic the effect of 15th-century country houses in England.

The reredos, pictured here without its statuary, is made of artificial Caen stone. The lightness of the stone lies in contrast to the darkness of the plain oak wainscot, giving some relief to the overall somberness of the chancel.

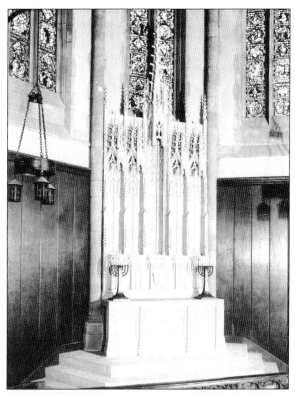

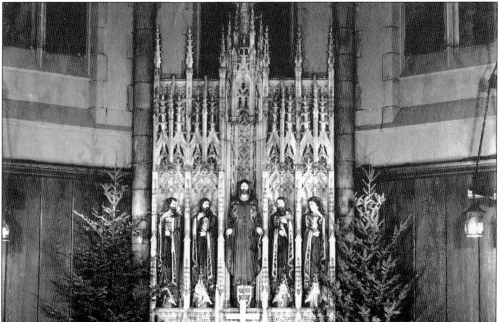

The altar is seen here complete. Pictured are the four Evangelists surrounding the center figure of Christ, whose hands are raised in invitation and blessing. Matthew (pictured far left) is represented by the figure of a man on a shield at his feet, next is Mark with a winged lion, then Luke and a winged ox, and John at the far right with a eagle.

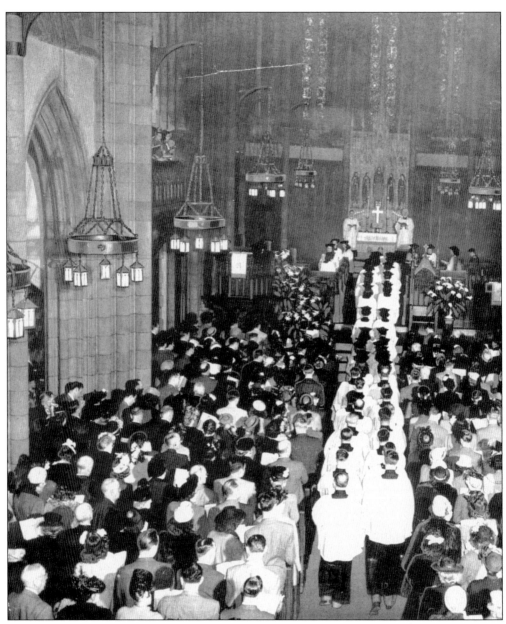

The dedication program was effusive in its praise of the new church's interior as well. "Passing through the front doorway . . . one enters the narthex, which is enclosed by a rich oak screen of open glazed tracery. The narthex, with its low, dark, beamed ceiling, emphasizes the lightness of the lofty clustered columns and the vaulted ceiling of the Nave; producing by contrast a startling effect of height and spaciousness. The warm, dark oak of the galleries, together with that of the pulpit, lectern, choir stalls and pews, gives a pleasing contrast to the grey of walls and masonry. A restrained use of gold and color also adds a desirable accent." The photographs here and on the opposite page are of Christmas services around 1940–1950.

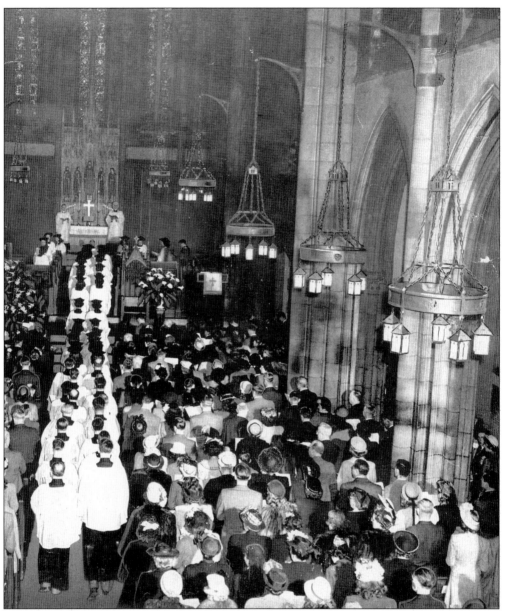

Trinity Lutheran is cruciform, or cross-shaped in design, with horizontal transepts that extend north and south, separating the nave from the chancel. Again the Gothic theme of verticality is emphasized: "In the church itself, tall molded Gothic arches define the side aisles; slender columns, some of them clustered, extend to the ribs of the groin-vaulted ceiling. This refined, richly detailed interior with its colorful windows and dark oak trim constitutes one of Akron's finest architectural spaces," wrote historian James A. Pahlau. Also of note are the church's metal fixtures, executed by Samuel Yellin of Philadelphia, a master metalsmith who was commissioned to do much of the work at F. A. Seiberling's great manor house, Stan Hywet. All exposed metal including lighting fixtures, locks, and hinges were designed by John W. C. Corbusier and created by Yellin with hammer and anvil.

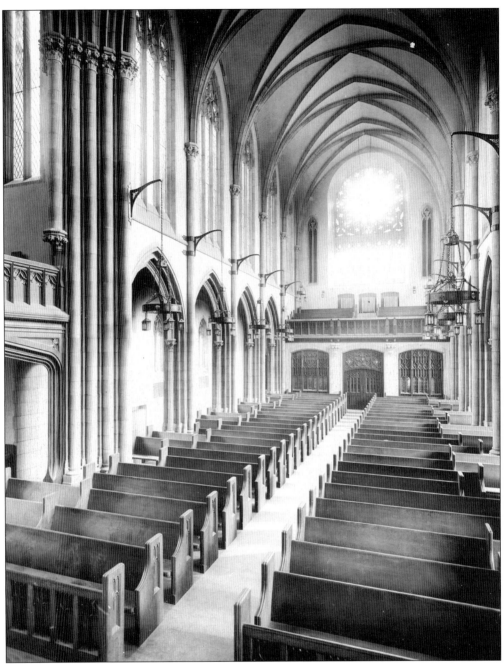

This interior view of the church looks toward the front of the building. Visible is the church's extraordinary rose window, donated in memory of Catherine Seiberling by her friends. As described in church literature, the window, emblematic of the divine law and ministry of Christ, "depicts the four Evangelists, representing the Ministry. Each occupies the four lancets flanking the central group of either side, and in the bases of these seven lancets are the ecclesiastical emblems of the figures above them. Surmounting the lower group of figures and in the center of the rose is the figure of the pelican feeding her young, emblematic of Christ shedding His blood for mankind."

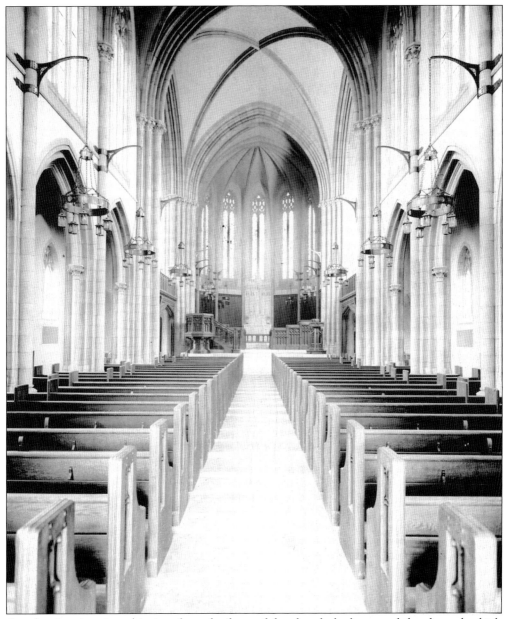

Another interior view, this time from the front of the church, looks toward the chancel, which is lighted by seven lancet windows, or tall narrow windows with a pointed arch at the top. Each one stands for the seven original churches mentioned in the book of Revelation, while the central three contain representations of the birth and boyhood of Jesus, the passion, and the ascension. Lancet windows were originally found in the great Gothic cathedrals of France during the first incarnation of Gothic architecture but were traditionally devoid of any tracery; not until the Gothic Revival period of the late 19th century were they subdivided and stained glass included. The richly carved octagonal pulpit, also of oak, is decorated with nine shields bearing gold symbols of the passion of the Savior. The lectern is of carved oak featuring the crossed keys, the symbol of St. Peter, the spiritual authority of the church, and the sword of St. Paul, representing his fervor in spreading the gospel.

Catherine and John F. Seiberling, one of the charter member families of Trinity Lutheran, were the parents of F. W. Seiberling, founder of the Goodyear Tire and Rubber Company. The church's massive pipe organ was donated by the Seiberling children in honor of their parents and was built by M. P. Moller of Hagerstown, Maryland. The factory, considered at the time to be one of the largest in America, built the organ to specifications as prepared by James H. Rogers, a noted Cleveland organist and composer. The organ was designed to harmonize with the architecture of the church, with the high-vaulted ceilings and open stonework of the nave providing exceptional harmony and tonal quality. The organ is located in specially arranged elevated chambers at each side of the chancel, with arches opening into both chancel and nave. In 1983, the organ was substantially expanded and rebuilt by Berghaus Organ Company and today consists of over 4,000 pipes in 72 ranks.

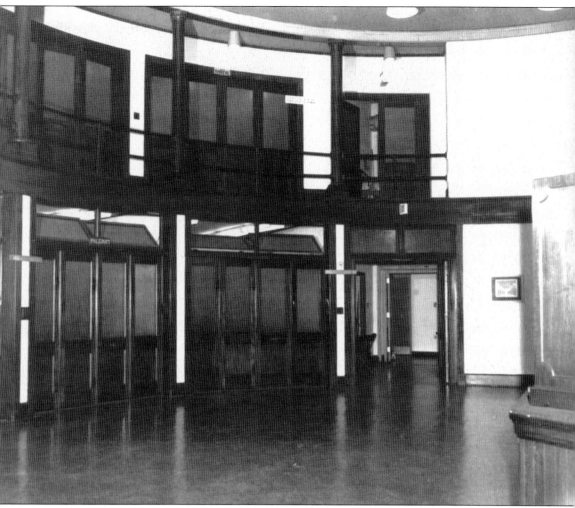

This is an outstanding photograph of Trinity Lutheran's Sunday school classroom built on the Akron Plan. Sadly, updates made to the church in 1964 have modified the distinctive layout beyond recognition. Once the new church was dedicated, the subject of starting a Sunday school was once again brought up, and on the second Sunday of June 1872, classes officially began with Pastor W. P. Ruthrouff as superintendent. An initial enrollment of 44 continued to grow; by 1949, crowded conditions necessitated building a separate religious education building.

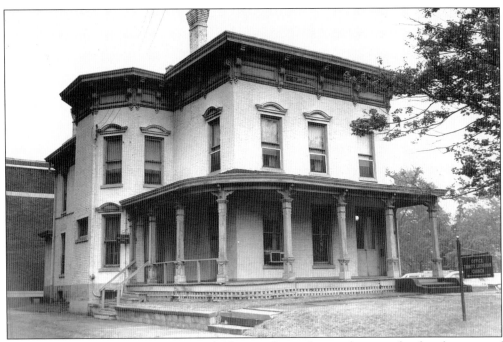

In November 1886, Rev. M. J. Firey of Altoona, Pennsylvania, became the fourth pastor of Trinity Lutheran. He was hired at a salary of $1,800, and this Victorian parsonage was built. Later it was used as an office building; in 1964, it was razed and a new addition built to house offices, Sunday school rooms, and other facilities.

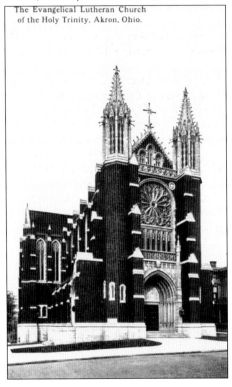

This postcard is of Trinity Lutheran in 1916.

Four

GERMAN ROMANESQUE REVIVAL

While St. Bernard is characterized as a Romanesque Revival structure, its style was imprinted with a distinctly regional flavor. In homage to the largely German congregation, the church was built in the German Romanesque style, one with a baroque influence that was designed to recall the great cathedrals in the Rhineland region of Europe.

German Romanesque architecture, more than any other variations of the Romanesque style, was rooted in the art and architecture of the era of the emperor Otto the Great of the Kingdom of Germany. It saw its greatest period of influence between the middle of the 10th century until the end of the 11th.

Ottonian architecture continued to rely on the Carolingian tradition, the heritage of Charles the Great (also known as Charlemagne), king of the Franks, a Germanic tribe of the Rhineland region in the early Christian era.

During his reign throughout much of the 10th century, under his direction Ottonian architects married the Carolingian tradition with its reliance on the designs of Byzantium and the Middle East with their own innovation, resulting in the unique character of German Romanesque.

Initiated in Carolingian times and carried through German Romanesque is the inclusion of a westwork, or tall monumental western entrance complex. The exterior of the westwork consisted of multiple stories between twin towers, while the interior included an entrance vestibule, a chapel, and a series of galleries overlooking the nave. Later the massive fronting and double towers concept would be adapted by Gothic and become the standard for a typical west facade.

German Romanesque churches were often planned on a large scale but show little interest outside the Rhineland area in utilizing a system of nave vaulting. Instead they continued to rely on the Carolingian idealization of Roman architecture and the basilica style. Indeed, early cathedrals of the Rhineland were built with wooden roofs, with vaults only added approximately 50 years after their widespread adoption in France.

The exteriors of German churches were never as richly decorated with sculpture as those in France and continued to employ the clustered towers and turrets and rugged masonry of Ottonian buildings.

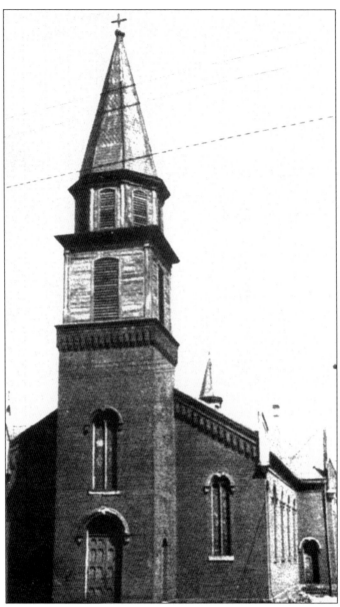

St. Bernard Catholic Church was the realization of a dream for 46 German members of the predominantly Irish St. Vincent Catholic Church. Desiring a church of their own, the group, calling itself the St. Peter's Bau Verein Society (*bau verein* is German for "building association"), met with Fr. John Luhr of Cleveland. The purpose of the society was to collect funds to build a German Catholic parish in Akron, and at that initial meeting a grand total of $2.75 was collected to build a church. Deciding its funds needed a boost, the society wrote to King Louis of Bavaria, who promptly responded with a $500 donation. On July 13, 1862, 2,000 people witnessed Luhr lay the cornerstone for the new church. Needing more funds to continue construction, Luhr offered an incentive: the person making the largest donation would have the honor of naming the brand-new redbrick church. His niece, Bernadine Luhr, made a $100 donation and selected her own patron saint, St. Bernard, abbot of Clairvaux, and the original name selected, St. Peter's, was dropped.

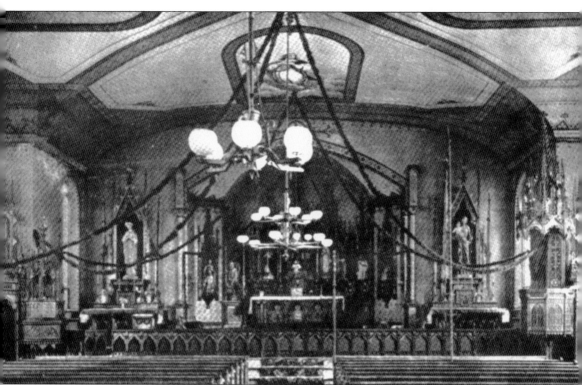

Less than one year after meeting with Fr. John Luhr, the cornerstone was laid on July 13, 1862, and the first mass was offered on January 1, 1863, by new pastor Fr. Henry Thiele. Only 140 feet long and 60 feet wide, the church was barely large enough to hold the growing congregation. By 1880, the length of the church had doubled and the tower had been added to the structure, with the *Summit County Beacon* reporting in November that the building "has been enlarged and remodeled, adding very much to the exterior, providing accommodations and beautifying the interior. The steady growth of the church and the want of adequate room were the principal causes in bringing about the improvement." After the parish moved into its new home in 1905, the old church was sold to the newly formed St. John the Baptist Slovak Church. Later St. Hedwig's Polish Catholic parish would also start its parish in the old building. Originally located at the corner of Center Street and Broadway Street, the land is now the current location of the National Inventors Hall of Fame.

On July 19, 1866, Fr. John Baptist Broun became pastor of the young parish, remaining so until his death in 1915. As the *Summit County Beacon* reported in 1889, "St. Bernard's Catholic Church, under the ministry of Father Braun [*sic*], is increasing every year." It was through his determination that St. Bernard established a school and built a church that would be called by Akron's mayor, a "new jewel in her diadem of sacred edifices."

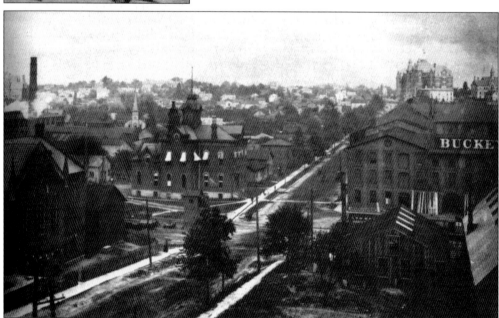

This photograph, taken in 1889 from St. Bernard School, looks east from Center Street. To the right is the old Buckeye Mower and Reaper Company; Buchtel College can be seen in the distance. To the left is the first St. Bernard Catholic Church, completed and occupied in January 1863. (Courtesy Summit County Historical Society.)

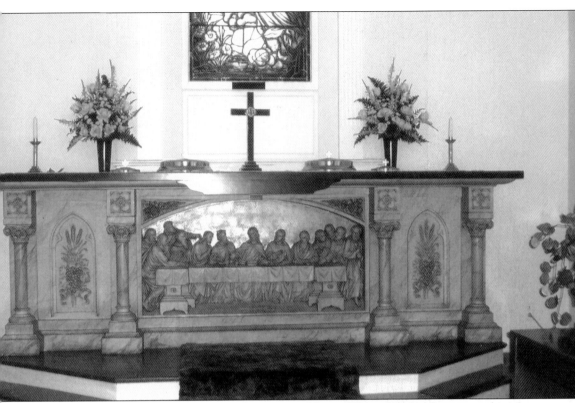

The altar from the Center Street church is pictured here. When the church was razed in the 1940s, Rev. Leo M. Gregory of First Christian Church in Stow, Ohio, happened to be driving by, and "noticed the old church was no longer there, just a pile of rubble, brick, stone and mortar lying around . . . everything except the altar." He purchased it for the grand sum of $25 (plus $10 to rent a truck to haul it away). The wood and marble altar is 10 feet long with a replica of the Last Supper along the face: Jesus is seated in the center with six apostles on either side. It is still in use today at First Christian. When St. John the Baptist Catholic Church vacated the property before its demolition, it took with it the Schantz pipe organ, the statue of St. John the Baptist, and the oak pews for its newly built church on Brown Street, where they remain today.

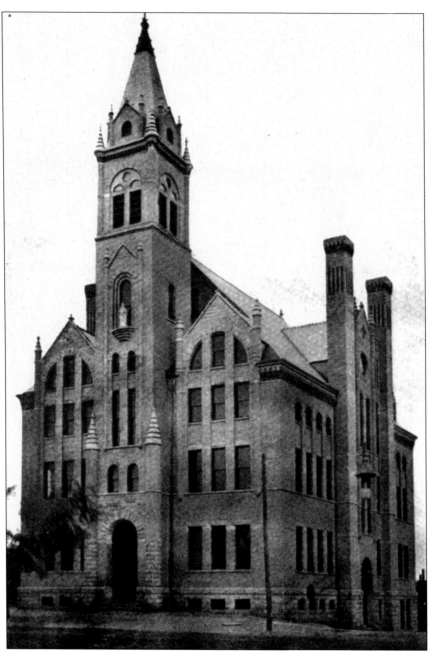

Once the original church was completed, Fr. John Baptist Broun set his sights on establishing a school, and in the fall of 1863, classes began in the church's basement. The school of 35 students and one teacher rapidly outgrew its small surroundings and Broun purchased the entire block of lots situated on the west side of Broadway Street between Center and State Streets, paying the sum of $9,000. The cornerstone for the new school was laid in August 1887 and was completed in 1890. The total cost of the school was $61,000, and when it opened, over 400 students were enrolled. Until the day it closed in 1977, the school never charged tuition. In the 1930s, the building was completely renovated, and the spire, roof, and third floor were removed as they were determined to be structurally unsound.

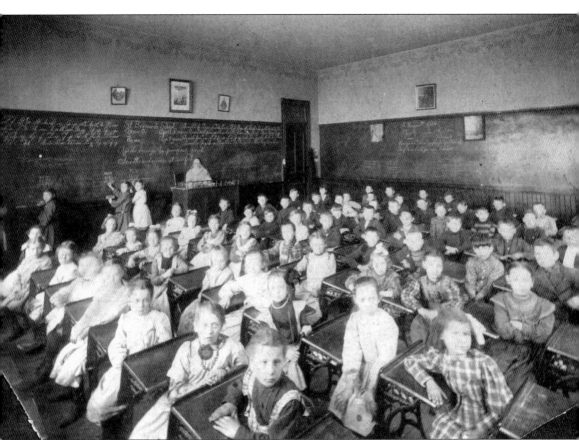

On the occasion of its dedication, the *Summit County Beacon* sent a reporter to tour the school with Broun and reported, "The building is built of brick with trimmings of brown stone. The outside dimensions are 72x100 feet, three stories high and basement, the basement being built of solid stone. A tower surmounted by a cross rises from the front center and is 138 feet high. The outer walls are highly ornamented and midway in the north and south sides tall ornamental chimneys rise above the roof, appearing like columns." The reporter went on to note the windows of plate glass and the front entrance under an arch. Wide halls ran through the building, with rooms of 72 seats "of the latest designs" off to each side. The school also contained a hall that held 1,000 people.

The school was originally run by the Sisters of Notre Dame, but on August 14, 1893, at the invitation of Fr. John Baptist Broun, 12 Sisters of St. Dominic arrived in Akron from Caldwell, New Jersey, to begin teaching. A few weeks later, they began their work, instructing 500 students.

The simple wooden structure where the sisters lived was built by Broun himself and became known as the "house by the tracks" as it was behind the church close to the railroad. It was used primarily for sleeping as daytime hours were spent teaching.

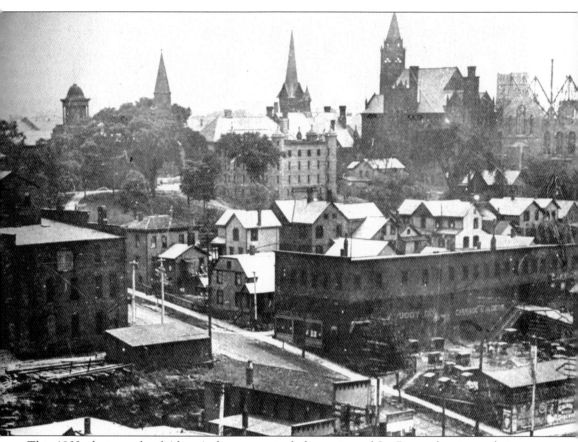

This 1903 photograph of Akron's downtown includes a view of St. Bernard as it was being constructed. Visible in the upper right-hand corner, the church would have two more years before completion. Construction on the church began in August 1901, when the first foundation stone was blessed and placed in position, while the cornerstone was set down in June 1902. The laying of the cornerstone, located at the State Street and Broadway Street corner of the church, was celebrated with a ceremony and parade that drew 7,000 area residents. A time capsule inside the cornerstone contained a letter from Bishop Ignatius Horstmann, a written history of St. Bernard, various U.S. coins in circulation at the time, and copies of Akron's English- and German-language newspapers published at the time. On the 100th anniversary of the cornerstone's placement, the time capsule was opened and displayed. After a mass celebrated by Cleveland bishop Anthony Pilla and a reception in the church hall, the original items, along with items from 2002, were placed in the cornerstone and resealed.

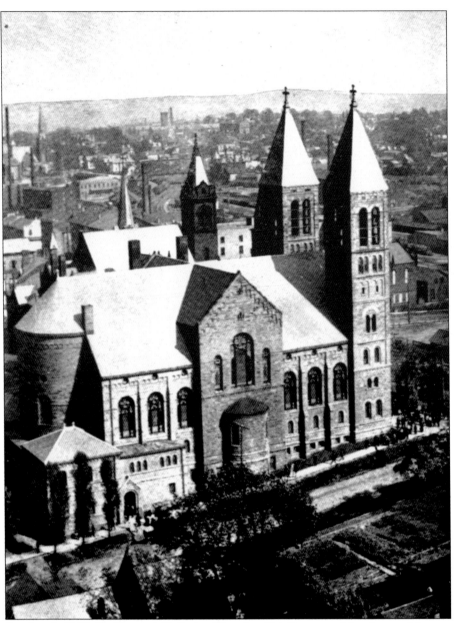

On October 8, 1905, St. Bernard Catholic Church officially opened its doors with an organ concert, open to the public. Tickets were $1 each and quickly sold out. Built at a cost of $160,000, the church was fully paid for at the time of its completion. At a time when the average yearly salary in Akron was $180, this was no small accomplishment. No encumbrances also meant that the church could be consecrated. In order to do this, canon law requires a church to be debt free, the altar to be constructed of stone and marble, and the altar stone to go down to the very foundation of the church. St. Bernard met these conditions and was formally consecrated and dedicated after a six-and-a-half-hour ceremony on Saturday, October 14, 1905, led by prominent bishop Ignatius Horstmann of Cleveland. As a consecrated church, St. Bernard will always remain a house of worship, serving no other purpose. Should the parish dissolve, then the church must be torn down.

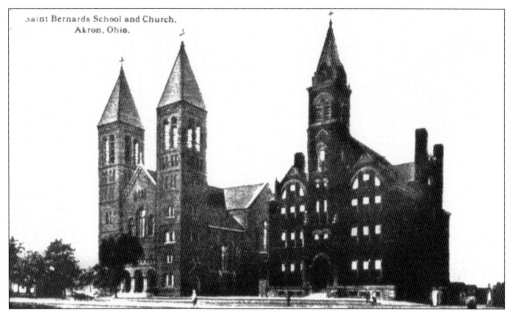

Saint Bernards School and Church,
Akron, Ohio.

St. Bernard celebrated its first mass on Sunday, October 15, 1905. A final mass, completed by 9:00 a.m., was celebrated in the old church, after which a parade of church dignitaries, church societies, and the pupils of the school led parishioners to the new building for a more elaborate pontifical mass. According to the *Akron Beacon Journal*, "The parade preceding the dedicatory ceremonies at St. Bernard's church was one of the prettiest sights witnessed in Akron for a long time." Attending the ceremonies were Ohio governor Myron T. Herrick and Sen. Charles Dick, along with various clergy from Akron, Cleveland, Canton, and Youngstown.

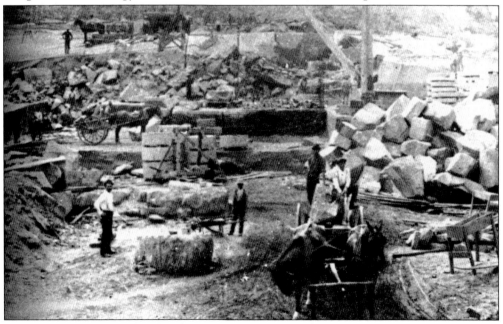

The sandstone used for the church was quarried locally. The contract to provide the 125 train carloads of stone needed for construction was given to Frank Lukesh of Peninsula Quarries for a total cost of $51,000. (Courtesy Summit County Historical Society.)

The arched entryways are typical of Romanesque architecture: heavily arched and deeply recessed. The influence of Richardsonian Romanesque is evident in the overall massive feeling.

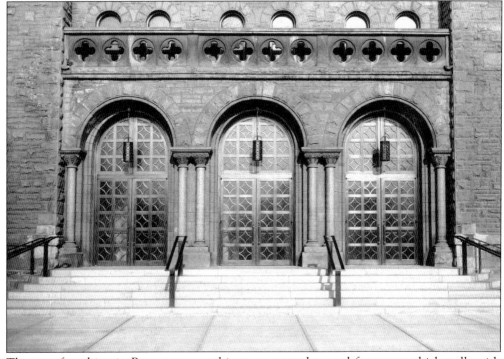

The use of vaulting in Romanesque architecture created a need for strong, thick walls with narrow openings to help support their weight. Arches, used here over the front doors, are another notable feature of the style.

P. E. Werner, a non-Catholic German, gave the keynote address the evening of the public concert. In his remarks, he noted that "it is not the money of millionaires that has made the erection of this church possible."

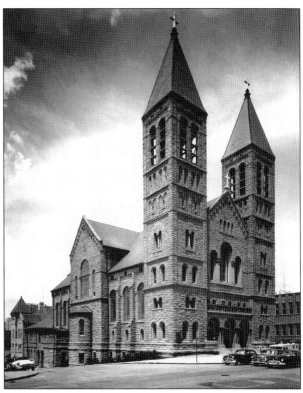

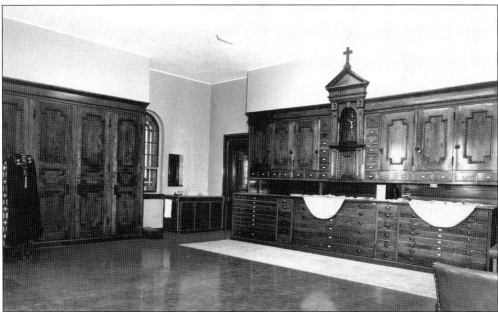

The sacristy at St. Bernard is seen here. Traditionally this is where vestments and other church furnishings, sacred vessels, and parish records are stored for safekeeping. The priest and attendants also vest and prepare before the service here. Here the sacristycredens, where the vestments are stored, is built in. It, along with the doors and other decorative trim throughout the room, is constructed of rich walnut.

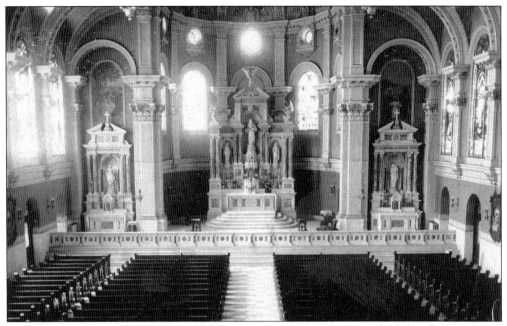

At the time of its unveiling to the public, contemporary newspapers called the church "one of the most beautiful churches in the United States" and "an ornament to the city." At a public concert held for the residents of the city, the church's gas lighting was used as the audience entered the church. However, before Akron mayor Charles W. Kempel began his address, the electric lights around the altars began to flash and then completely turned on, fully illuminating the interior.

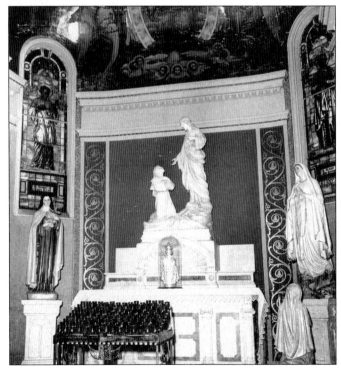

The Sacred Heart Chapel is seen here. The church's elaborate interior is accentuated with over 1,000 electric ornamental lights, hand-painted stained-glass windows donated by parishioners and imported from Germany, inlaid marble floors, and marble altars imported from Italy.

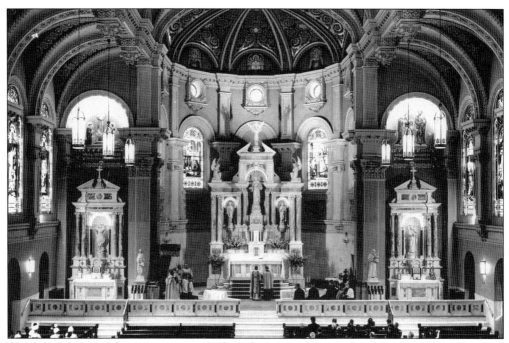

The communion rail, now gone, was built with the pennies of schoolchildren. Sister Bernard, who attended the school as a child and later served as a teacher, recalled, "You didn't dare leave home without your penny each week."

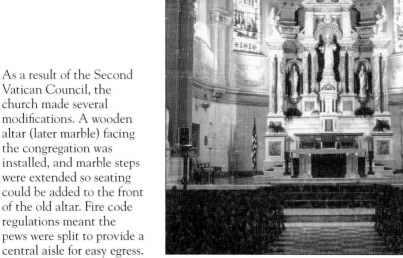

As a result of the Second Vatican Council, the church made several modifications. A wooden altar (later marble) facing the congregation was installed, and marble steps were extended so seating could be added to the front of the old altar. Fire code regulations meant the pews were split to provide a central aisle for easy egress.

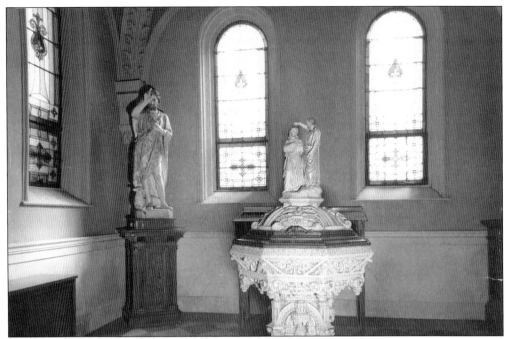

When immersion as the method of baptism was phased out in favor of infant christening, baptismal rooms were placed at the front of the church, symbolizing baptism as the "doorway" through which one entered the church. Today St. Bernard's baptismal font is located near the altar and the room used as a church history center.

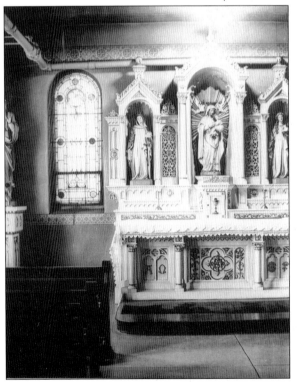

For reasons of economy, a full chapel, complete with side altars and confessionals and able to seat up to 850, was constructed in the basement of the church. It was used by the schoolchildren for their daily mass as it was cheaper to heat using simple potbellied stoves. In the 1950s, the chapel was taken apart and turned into a social hall. Pictured is one of the side altars, the Sacred Heart of Mary altar.

Akron's prominence as the "Rubber Capital of the World" came with a price. Heavy pollution expelled by the rubber factories, running on 24-hour shifts, caused a buildup of grime on buildings. Built of porous sandstone, St. Bernard was particularly susceptible, with the pollution rendering the beige structure nearly black.

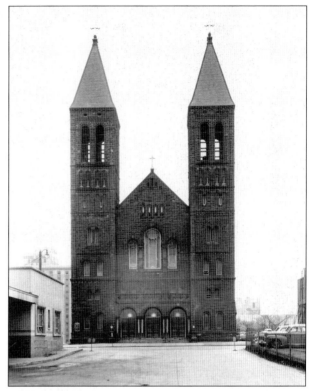

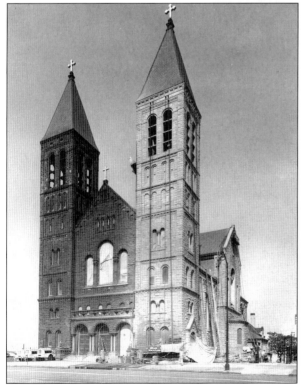

In the 1950s, the exterior of the church was cleaned to remove layers of grime. In 1995, the church was again washed as part of an overall restoration program that included cleaning the delicate, hand-painted stained-glass windows, repairing plaster, fixing leaks, and adding gold leaf to the trim along the painted ceiling.

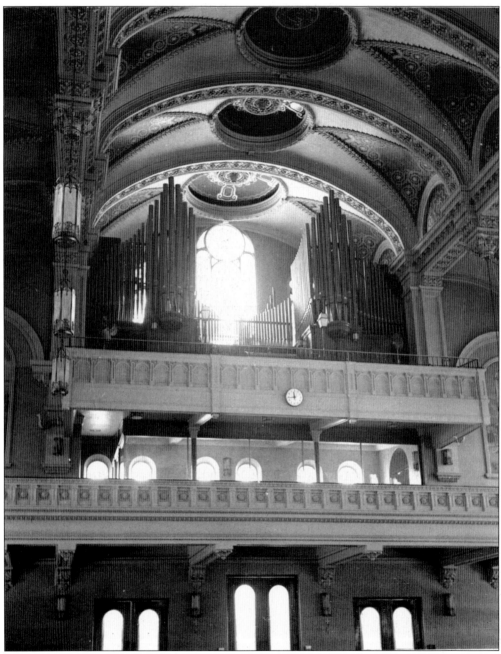

For over 100 years, the church's massive pipe organ has continued to delight generations of churchgoers. The organ, which required the use of over 8,000 feet of wood and the precise drilling of over 80,000 holes in the wind chests, has pipes "large enough for a man to crawl through" and "not much bigger than the last joint of one's little finger," reported the *Weekly Times Democrat*. Built by Schantz Organ Company of Orrville, Ohio, today the biggest challenge is keeping the organ tuned, replacing the leather bellows, and, at times, replacing the pipes themselves. The organ loft is graced by a large stained-glass window depicting St. Cecilia, the patron saint of church music.

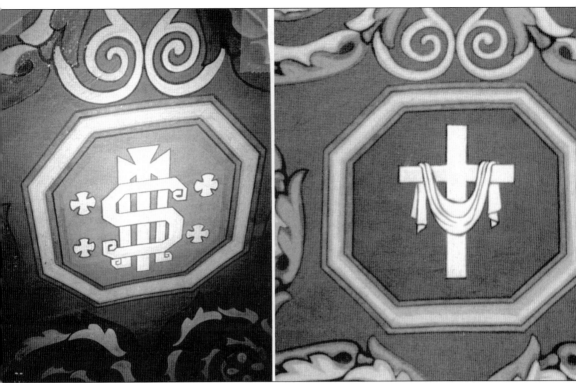

Architect William Ginther delighted in the practice of including a symbol in each church. For St. Bernard, he placed a juxtaposition of the letters *IHS*, a standard abbreviation of the Greek word for Jesus, above the altar. In 1996, during the church's restoration, Fr. Paul Schindler felt it looked too much like a dollar sign and requested it be repainted as a cross. To reach the top of the soaring cathedral during the restoration, extensive scaffolding was built to bring the workers within a few feet of the ceiling. Work on the interior included cleaning the elaborate frescoes and carvings and sealing them in polymer sheets. Much of the beautiful artwork, painted by "Cleveland's Michelangelo" Romeo Celleghin, was sketched and repainted by hand.

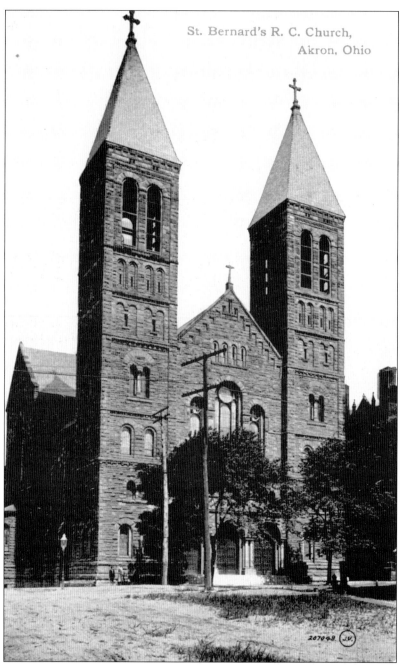

St. Bernard's R. C. Church,
Akron, Ohio

On March 9, 1989, St. Bernard Catholic Church earned the distinction of being listed on the National Register of Historic Places by the National Park Service of the U.S. Department of the Interior. The process, begun in 1984, was largely the work of the St. Bernard Memorial Trustee Advisory Board, which prepared and submitted the necessary paperwork. In December 1988, the church was notified by the Ohio historic preservation regional coordinator that he had approved the application. To honor this achievement, the Ohio House of Representatives issued a certificate of recognition, and the City of Akron approved a resolution honoring St. Bernard Catholic Church.

Five

RICHARDSONIAN
ROMANESQUE REVIVAL

During its revival in the latter half of the 19th century, Romanesque architecture showed itself to be a surprisingly flexible design style, as evidenced by the lasting influence of Henry Hobson Richardson.

Built between 1872 and 1877, Boston's Trinity Church is the building that established Richardson's design aesthetic, later becoming the blueprint for his subsequent works. A revival style based on French and Spanish Romanesque of the 11th century, Richardsonian Romanesque is generally characterized by the exterior use of massive walls of rough stone, dramatic semicircular arches, a massive tower, polychromy, recessed entrances and windows, and little carved or applied ornamentation.

While Richardson retained the details of Romanesque Revival, it is in their execution that Richardson's style is his own. The rounded stone arches of Romanesque are exaggerated into massive arched porticoes. Recessed loggias and groupings of windows demonstrate the thickness of the walls and provide an opportunity for elaborate stone detailing. These deep window reveals, cavernous door openings, and, occasionally, bands of windows were sometimes defined by a contrasting color or texture of stone or by short, robust columns. In the best examples, a single tower, massive and bold in outline, crowns the ensemble.

Perhaps the single most common quality of Richardsonian Romanesque architecture is its heavy, fortresslike form. Richardson's massive load-bearing masonry walls were often rough-cut, or rusticated, which added to the perceived weight of the structures. This defining characteristic, however, served to restrict the popularity of the style, as the construction technique of load-bearing masonry, rather than wood construction, brought the construction costs of Richardson's style up higher than its alternatives.

Richardsonian Romanesque was immensely popular in the Northeast, particularly in and around Boston. As the style moved west, its popularity began to wane in the east. Many of the stone carvers and masons who built in the style went west along with it until it died out in the early years of the 20th century.

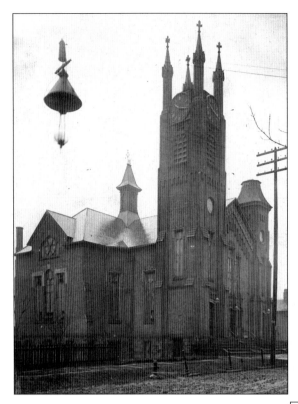

First Congregational was Akron's first formally organized church congregation. Chartered on November 3, 1833, the first building was located on South High Street, today the location of the Summit County Courthouse. In 1844, a new church was built at North Main Street and Tallmadge Avenue and the original, a small hand-hewed beam and clapboard-sided Greek Revival house, was sold to the Disciples of Christ and later Zion Lutheran. (Courtesy Akron-Summit County Public Library.)

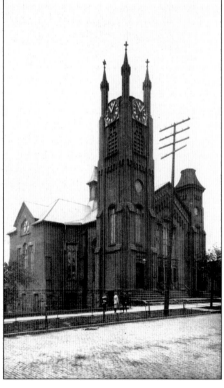

A devastating fire in 1868 leveled the Main Street church and the congregation built again, this time at 34 South High Street. In 1881, this building was also struck by fire but the church was saved and eventually restored. This photograph of the church in 1898 shows almost little to no changes as a result. (Courtesy Akron-Summit County Public Library.)

According to the *Summit County Beacon*, in 1889, "Church property including the church organ, etc., janitor's house and lot is valued at $30,000, a very low estimate. When the church was rebuilt after the fire there remained an indebtedness of $1,500 on that account and for a balance due on the janitor's house."

The organ in the High Street Church, above, featured beautiful stenciling on its visible pipes. In 2006, when the church's four-manual Casavant Freres organ underwent a massive renovation project, music director Valerie Thorson opted to remove the cover that had been placed over the organ and create a new facade, one based on the design of the High Street organ.

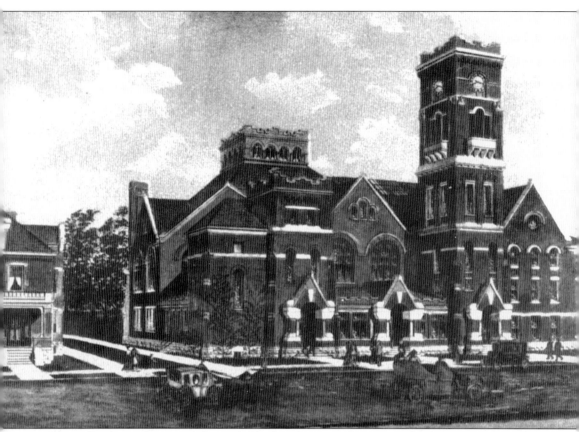

Originally the architectural firm of Charles Henry and son, Frank, Wagner and Mitchel envisioned a redbrick exterior for the new church. Instead the building was constructed in the Richardsonian Romanesque design, with its signature heaviness emphasized by Indiana Bedford limestone construction, deep windows, cavernous recessed door openings, bands of windows, and the distinctive clock tower crowning the building. Clearly the congregation had outgrown the church on High Street; as early as 1881 the *Summit County Beacon* reported Rev. T. E. Monroe mourning the fact that "there are now but 128 pews, so that every pew has at least two families assigned to it, while many have three and four families." This was discouraging church attendance "because where a family has only a couple of sittings for its half-a-dozen members, somebody always has to stay at home, and those who do . . . soon form the habit of staying away."

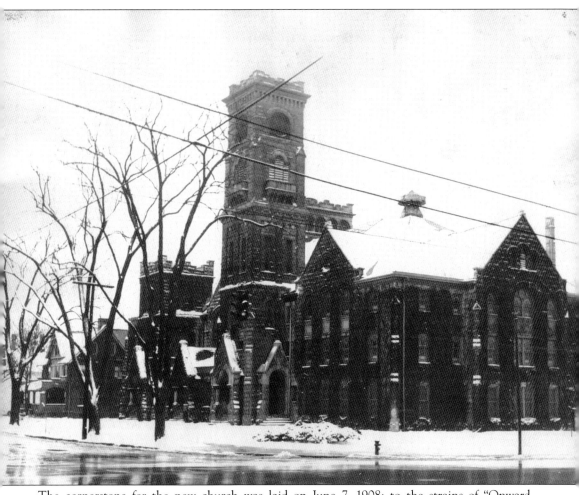

The cornerstone for the new church was laid on June 7, 1908; to the strains of "Onward, Christian Soldiers," the congregation marched from the High Street church to the new building to witness the historic event. Included in the cornerstone is a little copper casket containing the roll of church members, copies of Akron newspapers, the church constitution, a copy of the day's program, copies of church directories since 1866, photographs of former pastors, and a photograph of Mrs. Allen Hibbard, the only living charter member of the church. The inscription on the cornerstone reads, "This stone was laid in progress and faith for the perfecting of the saints, for the advancement of the cause of Christ on earth, for the cultivation of goodness in the lives of men, and the glory of God." The total cost of the new church was $100,000.

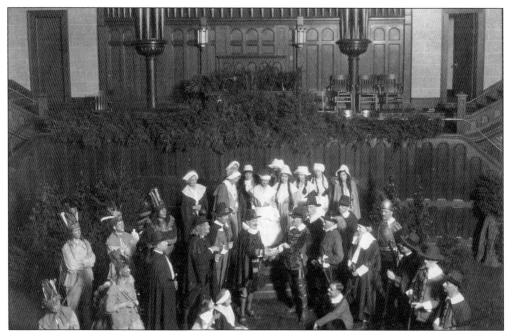

Despite ongoing construction, the first meeting at the new church was held in the Sunday school rooms on March 20, 1910. When the building was finally completed, the first official worship service in the new sanctuary was held on Christmas Day 1910. Here the congregation is celebrating Pilgrim Day.

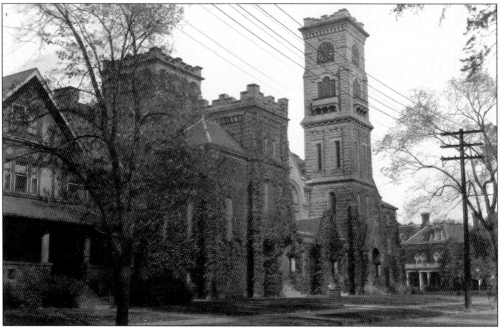

The church's signature clock tower has been an Akron fixture since the building was completed. Standing five stories tall at 100 feet high, the 18-square-foot clock tower has been struck by lightning several times in its history and required repairs each time. Nowadays the bell inside the tower is rarely rung; instead the chimes that sound the hour are electric.

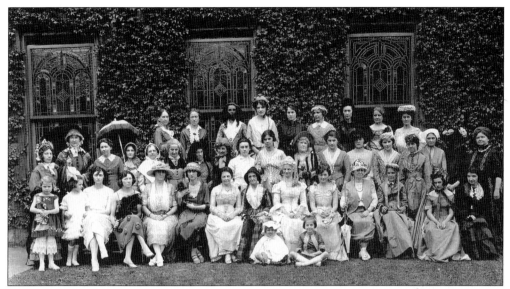

In 1834, the State of Ohio recognized the church's petition to incorporate, and in 1934, First Congregational held a 100th anniversary celebration. The women grouped in front of the ivy-covered church are dressed in costumes representing the various decades and eras throughout the congregation's history.

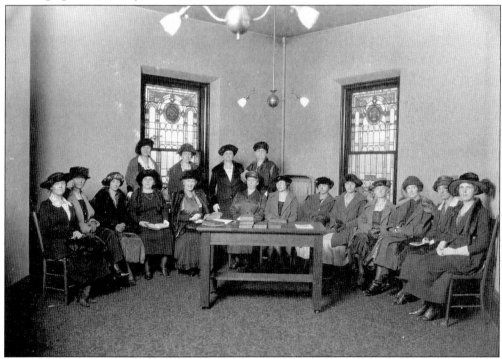

First Congregational has the distinction of having one of the last remaining examples of an Akron Plan Sunday school space in the city. In March 2004, the church's preservation of its Akron Plan resulted in its being listed on the National Register of Historic Places. Today only three original examples remain in the city of its birth. Above is a group of students in one of the Akron Plan classrooms.

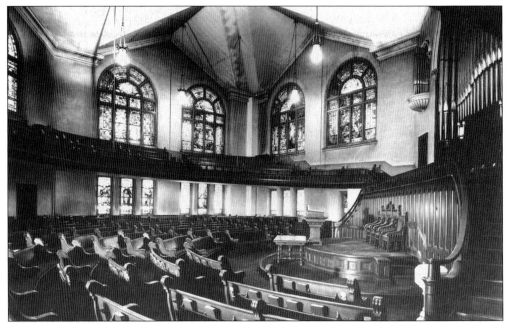

Despite the heavy appearance of his exteriors, Henry Hobson Richardson took care to create an interior that was spacious and dynamic in feeling. First Congregational's one-of-a-kind stained-glass windows help give the space a feeling of light and color. In 1998, they underwent a $190,000 cleaning and restoration to return them to their original beauty. Purchased by the church for a little over $9,000, the windows could not be duplicated today due to the level of craftsmanship involved.

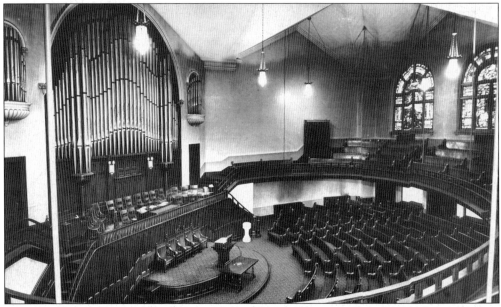

During the church's 2005–2006 restoration, the interior was refurbished and repainted in craftsman-era colors of gold, copper, green, and red. The woodwork and pews were cleaned and waxed, returning them to their beautiful original oak color. Ceiling tiles were removed, revealing decorative painting and original moldings. Stencil borders were also restored.

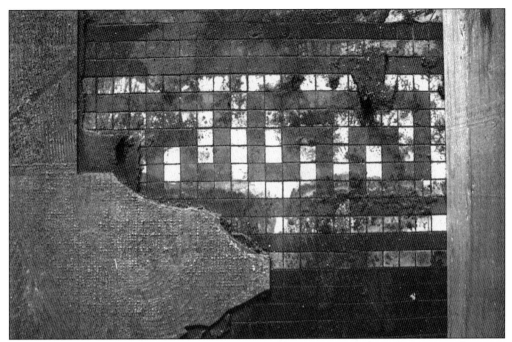

The restoration project also uncovered several hidden gems, including these original mosaic porcelain tiles in the narthex. "Improvements" in the 1950s, along with evidence of work done in 1913 and 1923 had covered these over in layers of carpet and linoleum. Cleaned and restored, they are once again a treasured feature of the church.

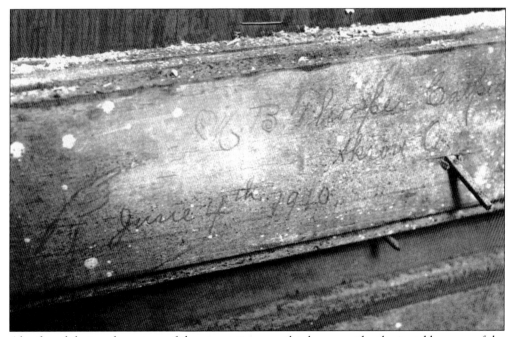

Also found during the course of the renovation was this beam, evidently signed by some of the original builders and dated June 4, 1910. The restoration was particularly sensitive to the original building materials; wherever possible they were left intact, only replacing what was necessary.

The parsonage, shown above, was eventually razed to make way for additional space. Over the years, First Congregational's pastors achieved national distinction, including Rev. Isaac Jennings, who created the graded school system also known as the Akron Plan. Rev. Howard S. MacAyeal was instrumental in organizing the YMCA and YWCA, and Rev. Lloyd C. Douglas wrote the novels *Magnificent Obsession* and *The Robe*, both of which were filmed by Hollywood.

The church's recreation center originally contained a bowling alley and a gymnasium. In 1958, First Congregational built a new wing that added a chapel, offices, meeting rooms, and a lounge to the existing church building. The recreation center was incorporated into the new wing and is now the entrance to the church's office area.

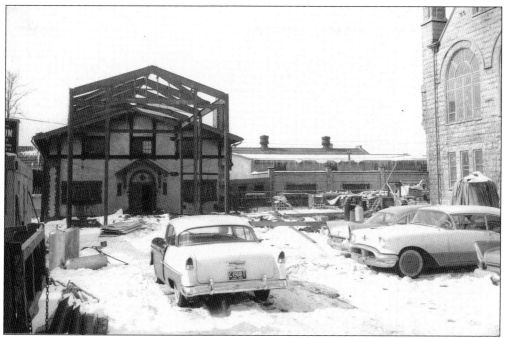

Surprisingly, while other churches of the era either gutted their Akron Plan layout or simply demolished it, First Congregation did not. In fact, many journals at the time published articles with suggestions on what churches could do with their outdated design. Today the two areas are separated by a permanent divider.

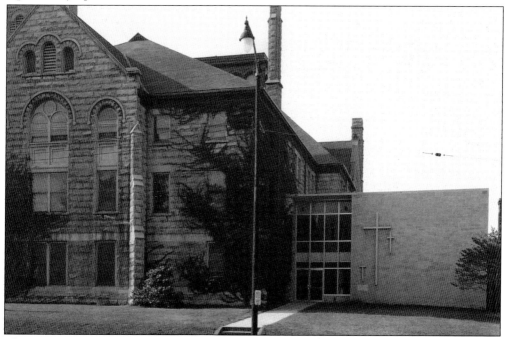

This is another view of the new wing, looking south toward the church from East Market Street. Curiously, the church's unique and beautiful windows appear to be covered up. The windows topped with trefoil tracery are the windows in the Akron Plan Sunday school classrooms.

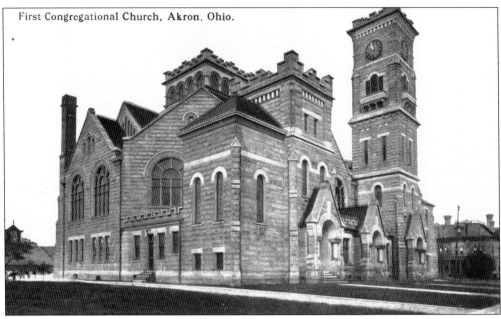

First Congregational Church, Akron, Ohio.

An interesting chapter in First Congregational's early history involves the church's third pastor, James D. Pickands. Not long after assuming his duties, he fell under the influence of "Millerism," or Second Adventism, in which founder William Miller proclaimed that the end of the world was set for April 4, 1843. Pickands's belief in Millerism split the church, with the defectors calling themselves the Second Congregational Church; when the Millerite faction fell apart, the church resumed its former name.

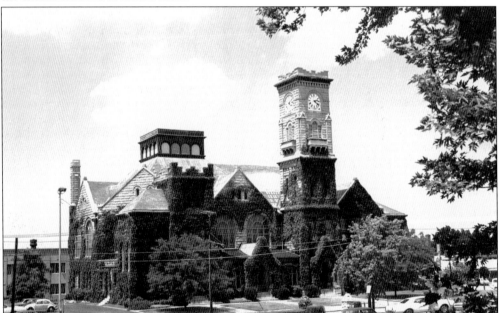

In a contest for "first church in Akron," many churches can make their own unique argument for capturing the title. But First Congregational has the distinction of being the first congregation established in a location that was Akron at the time. At the very least, First Congregational, established in November 1833, was Akron's first formally organized church congregation.

Six

NEOCLASSICISM

Neoclassic architecture is profoundly different from the earlier architectural styles that were more popular during the 19th and early 20th century. Unlike the heaviness of Romanesque, or the detailing in Gothic, neoclassic architecture is essentially austere. It is more calm and orderly than its stylistic predecessors, with its reliance on geometric shapes: the cube, the sphere, the pyramid.

Once again, Rome is the model; neoclassicism looks back to the Romans, adapting the Roman architectural grandeur of scale, simplicity of form, dramatic use of columns, and a preference for blank walls.

Unlike other design styles that use Roman influences as their base, it is the use of Greek architectural elements that distinguish neoclassicism; the complete temple front, with columns and pediments, are now used. If Rome is the model, then it is Rome as interpreting the Greek style.

Similar to Gothic, neoclassicism looks to geometry to achieve mathematical closeness to God. Unlike Gothic, however, neoclassicism is purely a style. Where the former strove to "reach up towards the heavens" in its upward orientation, neoclassicism is more a design aesthetic than it is a religious one.

Also similar to Gothic is the use of a tower or steeple as an essential feature. In many cases, towers were created using stories of decreasing size, eventually terminating in a small cupola or spire.

Neoclassic interiors are notable for their use of flatter, lighter motifs, sculpted in low friezelike relief or painted in monotones and medallions or vases or busts suspended on swags of laurel or ribbon with slender arabesques against backgrounds of pale tints or stone colors.

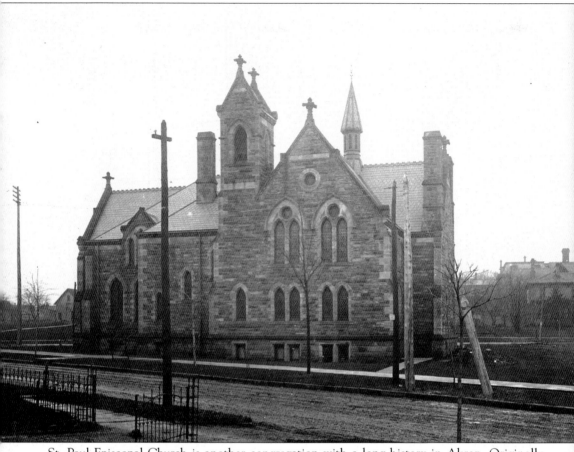

St. Paul Episcopal Church is another congregation with a long history in Akron. Originally founded in 1835 as a mission church of St. John Episcopal in Cuyahoga Falls, early meetings were held in the city's Old Stone Block on the southeast corner of Howard and Market Streets, also the location of a warehouse, jail, arsenal, and tavern. In 1840, a high wind toppled one of the chimneys and sent it crashing through the building, tilting the floor and sending many of the congregants into the cellar. In 1844, the 60-member congregation built a 20-foot-by-40-foot building on South High Street and after several enlargements decided to build a new church. The Steinbacher property, a triangular lot at East Market and Forge Streets and Fir Hill, was purchased for $10,000, and in 1884, a 72-foot-by-88-foot stone parish and Sunday school was built for $35,000. The cornerstone was laid on May 28, 1884, and dedicated on January 6, 1885. The High Street church was sold in 1885 to a Jewish congregation and turned into a synagogue. (Courtesy Akron-Summit County Public Library.)

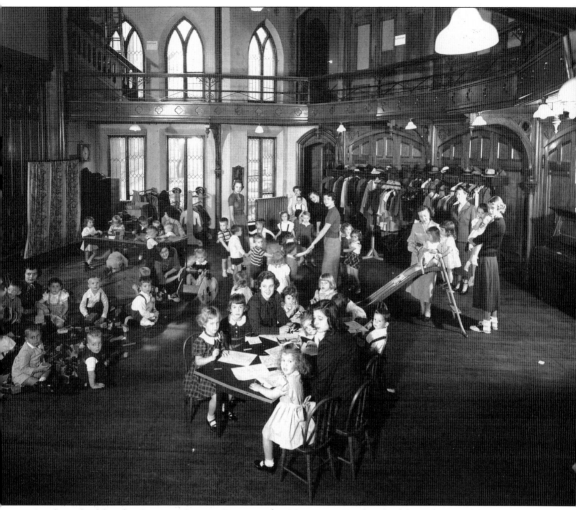

As described by the *Summit County Beacon*, the Victorian Gothic building designed by Akron architect Jacob Snyder "is constructed of native Ohio sandstone laid in regular rock-faced courses ending at finely-cut quoins at all projecting angles; and while Mediaeval precedent has not been strictly adhered to in fixing its architectural style, yet enough of this has been observed to classify its style with the pointed type of the Gothic." The Akron Plan classrooms are also described: "The radiating class rooms are connected with the central or main room by means of folding sash doors which, whether open or closed, do not obstruct a direct view of the superintendent's platform." The doors separating the classrooms are "not over elaborate, is yet pleasing in effect, there being a sufficient amount of carving to dignify the interior effect." The article goes on to describe the oak mantels, decorated tile hearths, frescoed walls, and "cathedral glass of appropriate design." The organ, brought from the High Street church, was originally made by E. and G. G. Hook and then rebuilt by Boddeler of Cleveland.

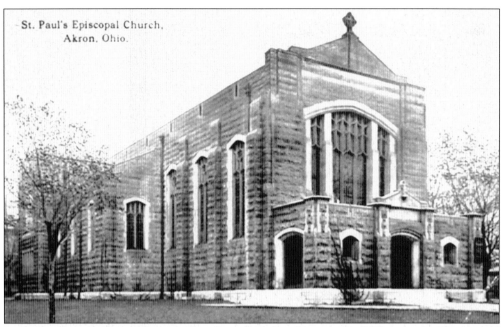

St. Paul's Episcopal Church,
Akron, Ohio.

In 1907, at long last, ground was broken for a new church on the Fir Hill property. The second building, of neo-Gothic design, was completed in 1907. Architect Frank L. Packard, who designed several Ohio state buildings, took over the project when the original architect, Milton Dyer of Cleveland, refused to modify his design to cost less than $60,000.

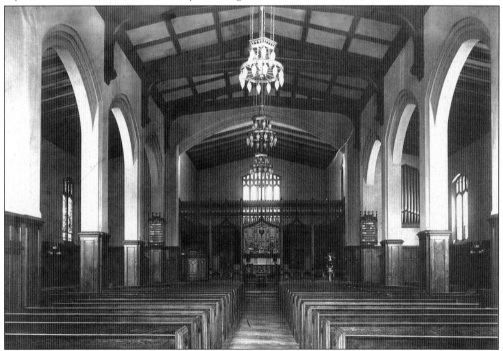

The groundbreaking ceremony for the new church was held on September 10, 1907, and the cornerstone was laid on November 3. The first service was held in the church on May 20, 1909, and on October 6, 1912, the building was consecrated by Bishop William Andrew Leonard.

In 1930, Rev. Walter F. Tunks became rector of St. Paul after a personal call from Harvey S. Firestone Sr. It was under his guidance that the church's finances were put in order. Later he championed the church's move to West Akron. Tunks is also well known as playing a role in the founding of Alcoholics Anonymous; as the story goes, Bill Wilson picked Tunks at random, calling to find fellow alcoholics with whom to talk.

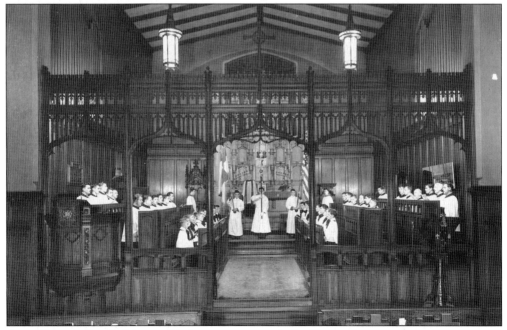

According to church history, "A beam transversed the Nave. On many occasions, nervous acolytes who were being careful not to trip down the altar stairs would bang the base of the cross on the beam. The cross, with the marks on it, remains today."

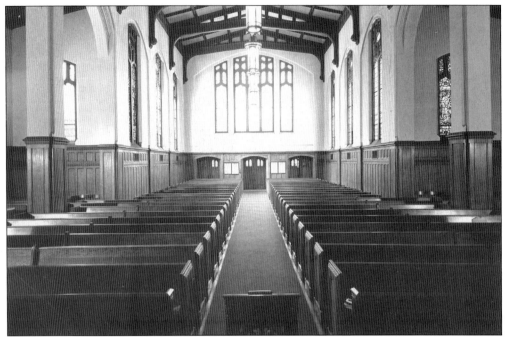

The nave in the photograph above shows the church was built in the basilica style with a simple barrel arched ceiling. Seating capacity in the new church was 500, with choir stalls that could seat 70. In 1930, the organ at the church on East Market Street was rebuilt and enlarged as a memorial to Mr. and Mrs. George W. Crouse by their children.

As early as 1930, the church was rapidly outgrowing the two buildings, but the deepening economic depression made the idea of raising funds for the expansion Rev. Walter F. Tunks was advocating less than palatable to the vestry. The idea was raised once again in 1939, but the outbreak of World War II created a shortage of building materials and the idea was shelved once more.

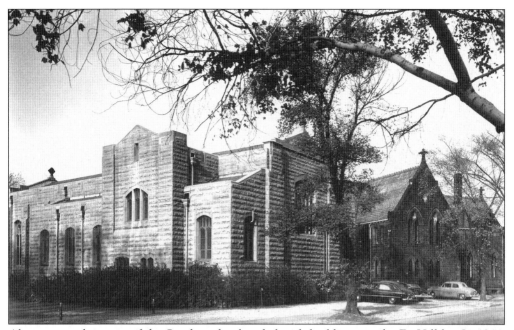

Above is another view of the Sunday school and church buildings on the Fir Hill lot. In 1944, the idea of a new church was revived with Russell Firestone's announcement of a gift to the parish, on behalf of the Firestone family, of a site for the new church. Later, once the move to West Market Street was completed, the buildings were sold to the University of Akron, which purchased them with a $125,000 donation from the Firestone family.

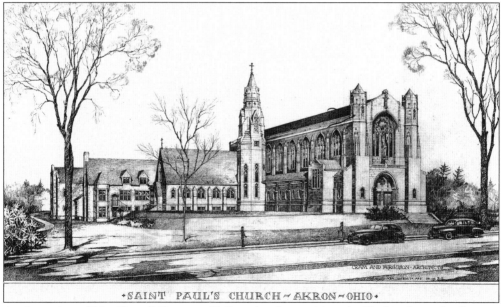

• SAINT PAUL'S CHURCH ~ AKRON ~ OHIO •

At the urging of Mrs. Russell Firestone Galbreath, who envisioned a Gothic design for the new building, the architectural firm Cram and Ferguson of Boston was called in to design a simplified Gothic structure. The architects' initial estimate of $750,000 was within budget; however, the lowest estimate from three contractors was approximately $1.5 million. A less expensive Colonial design was chosen instead.

St. Paul's Episcopal Church and Parish House
Akron, Ohio
Date: 10-2-50 View Looking Northeast
Cram & Ferguson Architects-Engineers
Carmichael Construction Co. General Contractors
Charles Mayer Studios Photographers

The location for the new church in West Akron was a gift to the parish from the Firestone family. The eight-acre lot, located at the corner of West Market Street and Kenilworth Drive, was the site of the family's former polo grounds. Ground for the new church was broken on July 9, 1950.

Once the foundations were in place, a small amount of masonry laid, and a few pieces of structural steel erected, it was time to lay the cornerstone. On November 5, 1950, Rev. Dr. Walter F. Tunks, Bishop Nelson M. Burroughs, and members of the congregation watched as the cornerstone was set into place.

A copper box containing church records and instant photographs of the day's events were included in the cornerstone. A mechanic on hand soldered the lid on the box, and a mason grouted the box, sealing it within. Bishop Nelson M. Burroughs then struck the stone three times with a trowel, saying, "I lay this cornerstone in the name of the Father, and the Son, and the Holy Ghost. Amen."

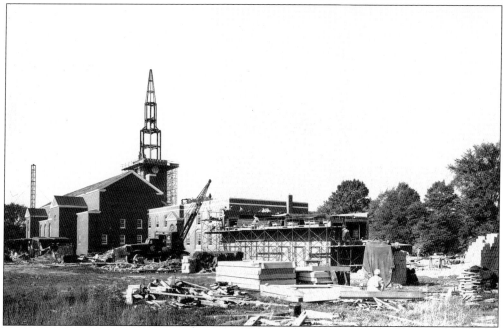

As construction of the church progressed, the budget continued to rise. An assembly hall had been part of the original plans but was eliminated to save funds. Later as construction continued, the need for a hall became evident, and to raise funds and generate interest, a small-scale model of the hall was created and put on display.

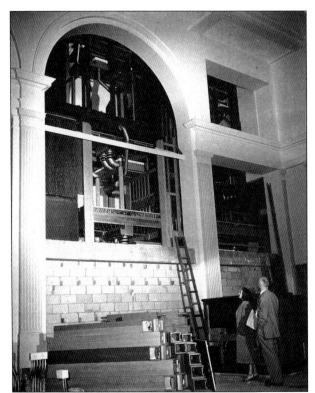

After careful consideration, choirmaster Ralph Clewell selected Moller of Hagerstown, Maryland, to build the organ for St. Paul. Originally estimating the cost at $50,000, the organ went way over budget, particularly due to enhancements Clewell insisted on adding. The Moller organ contains over 4,522 pipes distributed through 72 ranks and ranging in size from that of a pencil to 32 feet long.

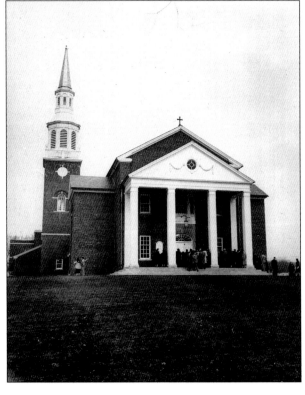

This is St. Paul Episcopal as it looked at the time of completion. Once the church was finally completed, the final cost of construction was $1.5 million. Later a chapel was added to the left, and additional classrooms, offices, and meeting rooms were added to the right.

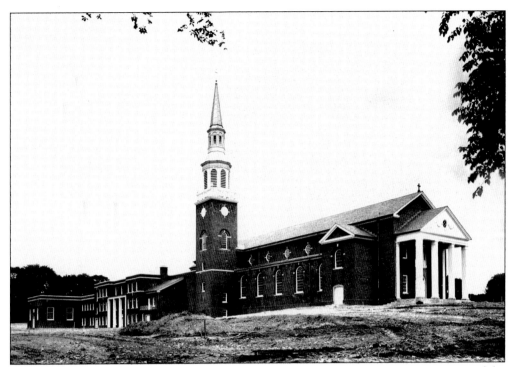

The last service at the old church was held on November 23, 1952, and the consecration of the new church held the next day.

On Tuesday, November 25, 1952, at 2:00 p.m. the Right Reverend Nelson M. Burroughs consecrated the new St. Paul Episcopal Church. After knocking on the door, to the sounds of the choir singing, "Onward, Christian Soldiers," Burroughs was welcomed into the church, and the service for the consecration of the new church began.

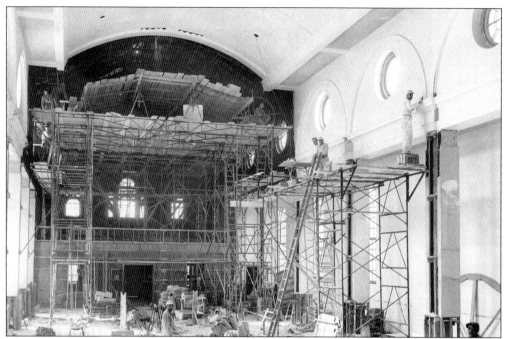

Original plans for the church included installing a parquet floor in the nave. As costs continued to mount, plans were changed to use asphalt tile instead. After learning of the substitution, Harvey Firestone Jr. brought in a piece of parquet flooring from a French baronial mansion, asking it be re-created in walnut and saying that a way would be found to pay for it.

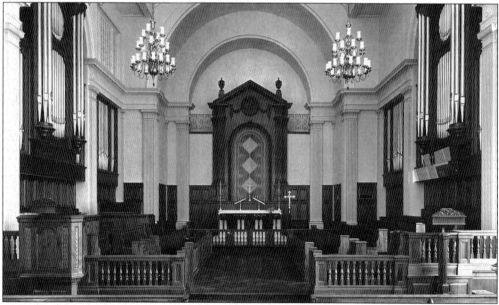

Several mementos were incorporated into the church after its construction. In the nave is a frame with a stone from Canterbury Cathedral along with a brick from the first Anglican church built at Jamestown, Virginia. In the reredos is a piece of marble from the reredos of St. Paul's Cathedral in London, and on the wall of the east staircase of the narthex are the cornerstones from the 1885 and 1909 churches.

At the request of the architects, the pews, pulpit, lectern, choir stalls, reredos, and railings were all made of walnut that was naturally dried for at least 10 years. Enough wood for the project was found in a small furniture factory in Ontario; before it could be imported, the church waited for a ruling from the Internal Revenue Service asking that it be brought in duty-free for ecclesiastical purposes; it agreed.

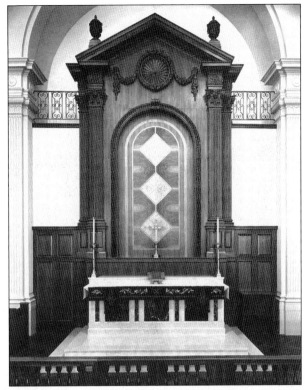

The detailing on the reredos needs to be viewed up close to appreciate the careful workmanship. The architects deliberately specified aged wood, believing anything new would be unsatisfactory and prone to cracking and warping over time, but matured walnut would stand the test of time.

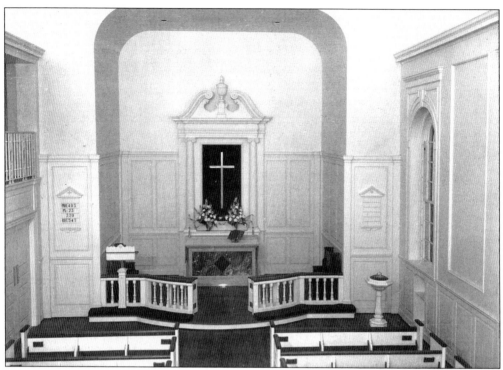

In 1956, the Firestone brothers donated the funds necessary to build the proposed chapel as a memorial to their mother. Completed in 1957, the Idabelle Firestone Memorial Chapel houses the organ from Harbel Manor, the Firestone family home. The original plans for the chapel had to be enlarged to accommodate the Aeolian organ, which was rebuilt before its installation.

Early supporters of St. Paul Episcopal included the Honorable George W. Crouse (left) and match king Ohio Columbus Barber. While the Crouse family remained parishioners for many years, constant clashes with church elders drove Barber to leave.

Seven

OTHER AKRON CHURCHES

After the completion of the Ohio and Erie Canal, Akron's resurgence as a manufacturing center kept many of the canal workers here. That being so, many congregations having their beginnings in the 1830s and 1840s is a testament to the roots that were being laid by immigrants who had come to work on the canal.

No expenses were spared in the building of these churches. What cost $45,000 to build in 1884 would cost nearly $1 million today; that these were built at a time when wages were approximately $3.50 per day makes their construction no less remarkable.

The design choices made for these churches were based on the prevailing styles of the 19th century. Romanesque and Gothic and their various iterations remained the most popular: Romanesque with its roots in the classic elements of intellectual Rome and Gothic with its mathematical precision that nonetheless managed to achieve breathtaking beauty.

While Akron was influenced by others in the construction of churches, in an amazing twist, Akron was able to influence the construction of others. The contribution of Lewis Miller and Jacob Snyder and their Akron Plan design is no small achievement, as evidenced by the adoption of the plan by denominations and architects across the country.

Akron is fortunate that so many of these early churches still stand. While many have been lost, fortunately through the dedication of their parishioners they continue to bring joy and comfort to both members and nonmembers alike.

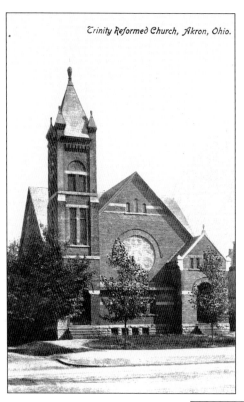

Trinity Reformed Church, Akron, Ohio.

In 1890, the congregation of Trinity Reformed Church was organized, with a charter membership of 84. Originally the group met in Mattie Leib's vacant grocery store on York Street, but after only two months, its first church was built. The congregation remained there only three years; growth required the building of a new church, this time of brick.

On June 21, 1893, the cornerstone was laid for the church's new building on the corner of Howard and York Streets and the old church sold to the fire department for a North Hill station. Dedicated on May 18, 1894, the church remained the congregation's home until the completion of the new church in 1928.

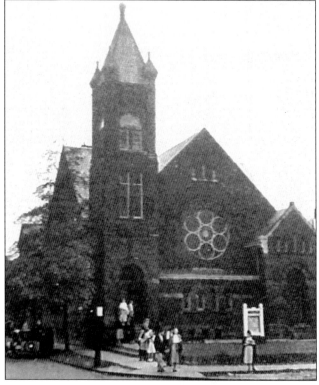

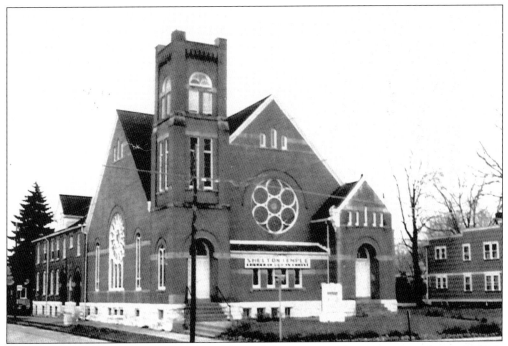

In anticipation of moving, the church on Howard Street was sold to a Pentecostal group, which worshipped with Trinity until the latter's move. A facsimile of the Howard Street church is in the glass of the window above the balcony of the present church.

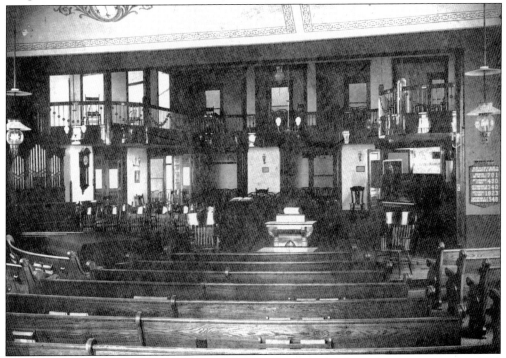

The original wood chapel was still being used as a Sunday school, until it was replaced in 1911 with a new building using the Akron Plan design.

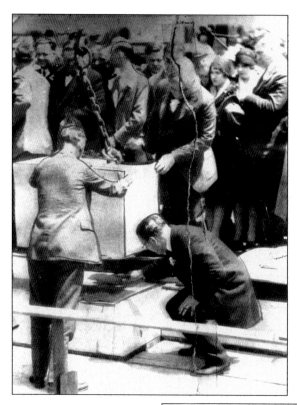

In 1925, a lot had been purchased on North Main and Dalton Streets for the new church, and ground was broken on November 13, 1927, the cornerstone laid on May 13, 1926, and the dedication on March 3, 1929. The church was completed at a cost of $300,000, which today would exceed $6 million.

The main entrance to the church is filled with elaborate carvings heavy with symbolism. The keystone of the entrance is the shield, representing the Holy Trinity. The narthex is partitioned from the nave with beautiful panels and leaded glass. Inset in the glass are four emblems: the fleur-de-lis, the open book, the cross and crown, and the anchor.

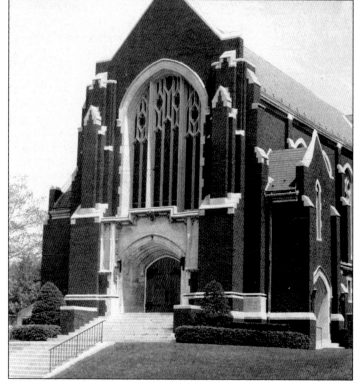

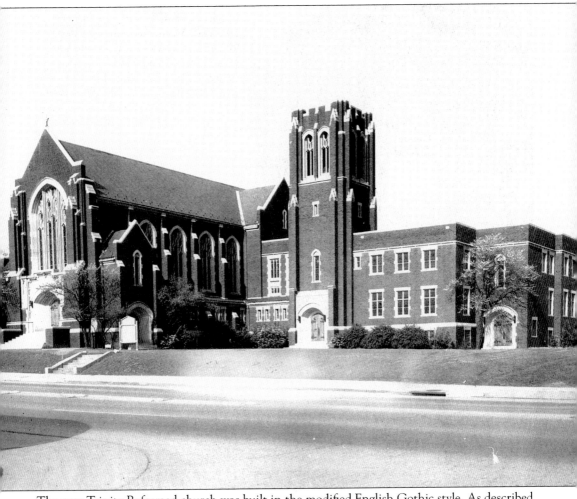

The new Trinity Reformed church was built in the modified English Gothic style. As described by the dedication program, "[The Gothic style] was not only a reaction in the art of building but also in the soul of men in their desire to worship God. The gothic arches which are evident in our building remind one of the attitude of the worshipper with folded hands uplifted to Heaven. A house of worship to be most significant must in every aspect of its construction lift the thought of the worshipper far and beyond the commonplace of life to a God who is high and exalted in Heaven, and so we have the gothic in order that as we enter its beautiful portals, our thoughts are at once influenced by the atmosphere created, without and within, by these beautiful lines."

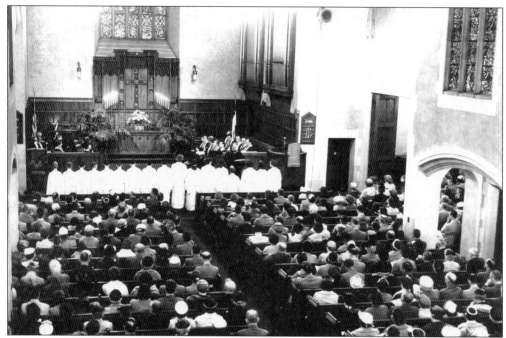

The church is cruciform in design with a high, narrow nave. The sanctuary is approximately 30 feet deep, with the pulpit on the south and the lectern on the north, with wainscoting running into the reredos. The reredos features the story of the cross, with linen fold carvings on the extreme panels to suggest a hanging piece of tapestry. The Tellers-Kent organ is screened with hand-carved grills filled in with pipes decorated in old gold.

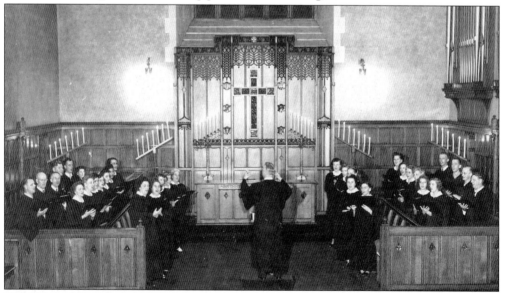

Highlights of the church include its numerous carvings and elaborate stained-glass windows. The windows' rich colors, designed by Pittsburgh Stained Glass Studios, were achieved by mixing arsenic into the molten glass. The centerpiece of the church is its Resurrection window, located above the communion table in the chancel. It has five lancet windows and many templates of stone tracery at the top.

The chapel features a wood-beam ceiling, similar to the ceiling in the nave. The pews are also laid out in the same style as the sanctuary; doors between the two can be opened for additional seating when needed. The cloister aisle is continued from the church into the chapel and forms a foyer, screened as the narthex is with wooden panel and glass.

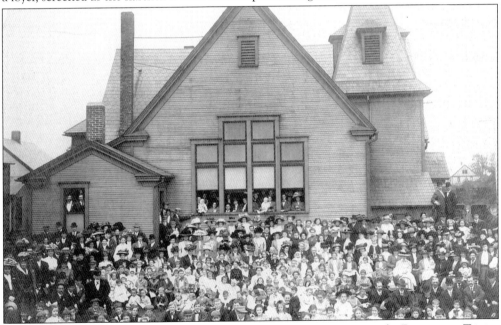

The Wooster Avenue Reformed Church is seen here around 1910. During the Depression, Trinity Reformed was facing severe financial difficulties. Wooster Avenue, in the meantime, was looking to raise funds and relocate. Leaders of the two churches, along with the synod, met to discuss a merger, and on July 14, 1940, the two congregations worshipped as one.

On March 4, 1945, the church held a mortgage-burning party and was officially debt free. The church's continued growth allowed it to expand and between July 1955 and July 1958, $165,000 was raised to help build an addition to the church. The area above has since seen a wing added to the church that houses Sunday school classrooms and offices.

For over 80 years, Trinity Reformed—now Trinity United Church of Christ—has had its home in Akron's North Hill area. This aerial photograph shows not just the neighborhood but another quintessential piece of Akron history; Trinity Reformed is below the airship in the center.

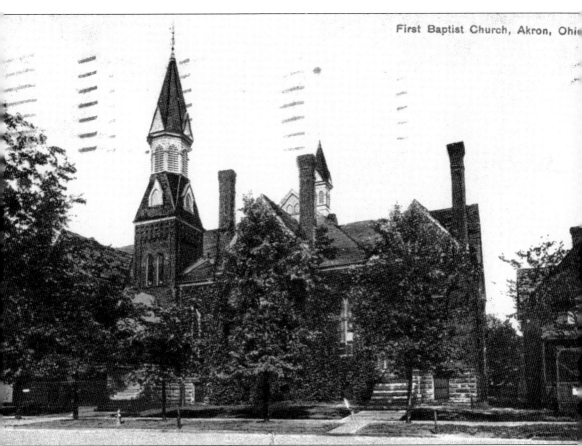

In 1836, Akron and Middlebury Baptist Church built its first place of worship in the Gore. Unlike the other churches, the Baptists built their church facing south, antagonizing their North Akron congregants; the controversy nearly split the church with many members leaving. In 1858, the church sold its building to the German Reformed Society and purchased the original Universalist Stone Church on North High Street, holding its dedication service on June 17, 1853. In 1889, the church purchased a lot on Broadway Street between Mill and Market Streets for $10,000 and built this Akron Plan church for $30,000. Designed by Akron architect Jacob Snyder, the building was brick, with stone and decorated pressed-brick trimming. The main entrance featured a gabled arch, while two domes towered above, one over the main entrance and one near the southeast corner. The walls of the church and Sunday school were frescoed, and both areas featured fireplaces with terra-cotta tiles. In the mid-1960s, the congregation moved to the West Akron/Fairlawn area, and in 1988, arson destroyed the church.

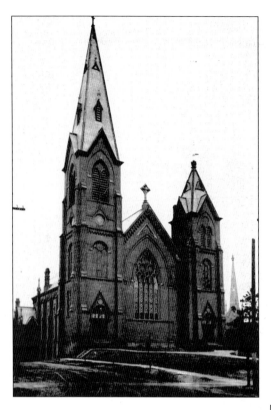

One of Akron's oldest congregations, it is thought that First Methodist Episcopal Church began holding services as early as 1830. By 1835, it was an established congregation and in 1836 built its first church in the Gore on the corner of Church and Broadway Streets. On March 17, 1841, the building was destroyed by fire. (Courtesy Akron-Summit County Public Library.)

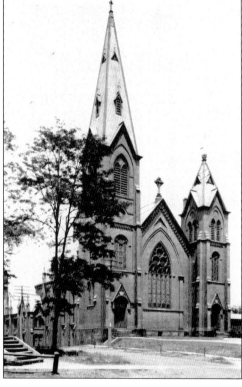

The church was soon rebuilt on the same location, once again facing west to avoid controversy. In 1861, the building was enlarged and remodeled at a cost of $3,500. In 1866, $30,000 was donated for the building of a new church that would be "a credit to the city." In 1871, the new church, above and right, was completed at a cost of $128,000 and dedicated in 1872. (Courtesy Akron-Summit County Public Library.)

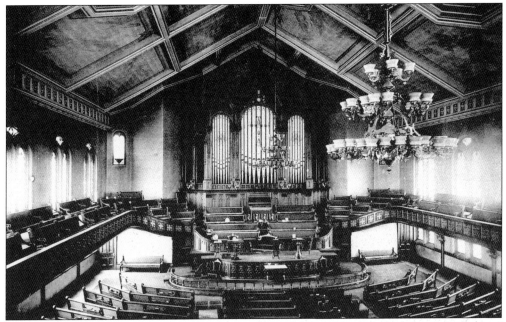

The original home of the Akron Plan, the layout was planned by architects Jacob Snyder and Lewis Miller to include the new formation of semicircular Sunday school rooms located behind the congregation. It was a design that would be copied by nearly every Methodist and Presbyterian church in the country until it died out in the early 20th century. In 1911, the church burned to the ground. (Courtesy Summit County Historical Society.)

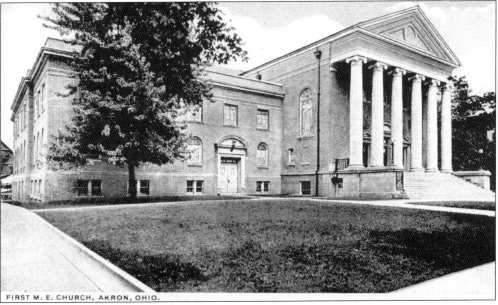

FIRST M. E. CHURCH, AKRON, OHIO.

The church's leaders voted to sell the church property to the city, and the Akron Armory was built on the spot, where it remained until its demolition in 1982 to make way for the Oliver R. Ocasek Government Office Building. First Methodist built a new church at 263 East Mill Street, breaking ground on June 30, 1913, and dedicating the new building on October 25, 1914. In 1994, the church burned and was rebuilt in 1997.

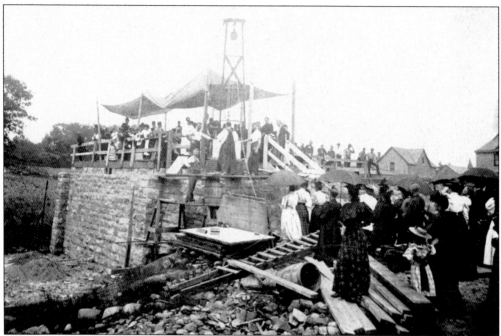

As the West Hill neighborhood in Akron continued to grow, many members of St. Paul began to desire a church closer to home. A mission church was formed in 1892, and in April 1895, Church of Our Saviour was officially a parish. A building committee was established, and in 1894, the group purchased a lot on Crosby Street for $600. The cornerstone for the $5,100 church was laid on June 13, 1895, and construction was completed in 1896.

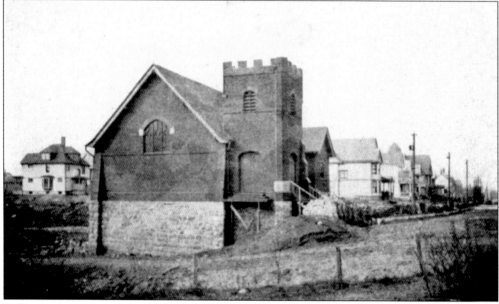

In his memoirs, former pastor George Atwater described the little church upon his arrival: "It was a small structure of brick veneer, perched upon an imposing foundation. For it had been built in a hollow, and solid earth was twelve or fifteen feet below the sidewalk level. Consequently the foundation walls were massive piles of solid masonry, exposed on three sides."

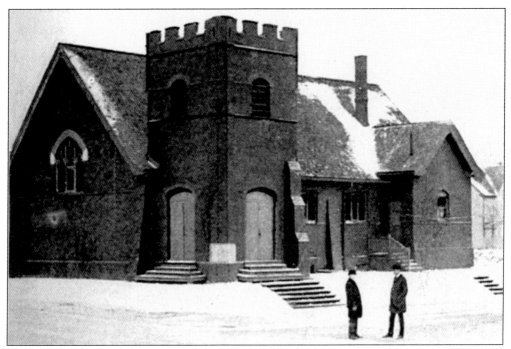

George Atwater went on to describe the interior as "very plain . . . The Altar stood against the north wall, at a point on a line with the fourth pew in the present church. Upon the left of the narrow chancel a choir loft contained a tiny organ, and a few chairs for singers." Despite its undeveloped atmosphere, Atwater was charmed by the church, remaining as pastor until 1928.

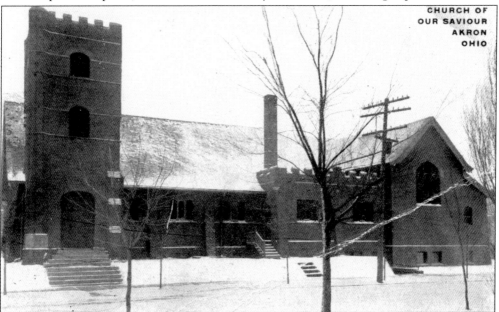

CHURCH OF
OUR SAVIOUR
AKRON
OHIO

As the congregation continued to grow, Church of Our Saviour was rebuilt. Designed by Bunts and Bliss, the total cost of the project was $15,000. The south end of the original church was retained, with the expansion continued to the north. In November 1905, the enlarged church was dedicated.

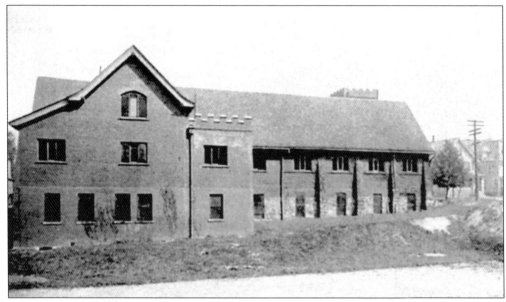

In 1898, the interior of the church got a boost from Henry C. Corson. After meeting George Atwater at a charity ball, Corson offered to cover the cost of choir stalls. For $110, the church received quarter-sawed oak choir stalls, a prayer desk, a two-seated chancel stall, and a screen.

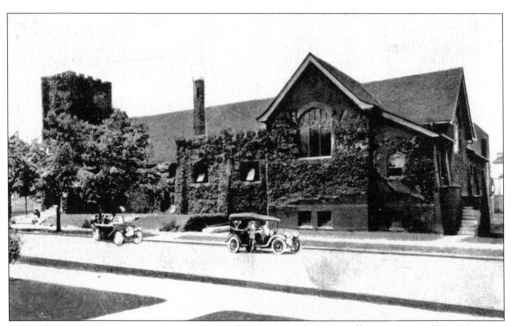

After the expansion construction was completed, the old choir stalls were moved into the new church, along with the lectern and the altar, which was replaced in 1913. A pulpit was built using the old altar rail for a frame, then covering the panels with tapestry cloth. It was replaced in 1925.

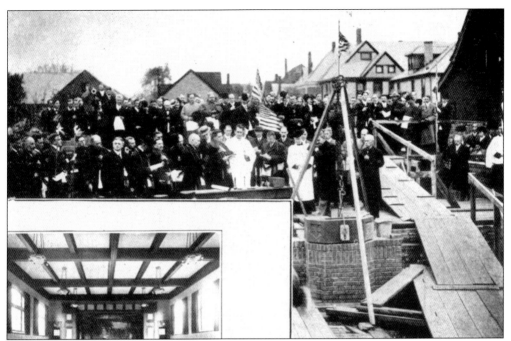

In August 1911, ground was broken for Church of Our Saviour's Marvin Parish House and the cornerstone laid on October 22, 1911. Initial funds for the project were donated by Mrs. Richard P. Marvin in memory of her husband, with additional funds given to the church by Charles Goodrich. The building was completed on July 1, 1912.

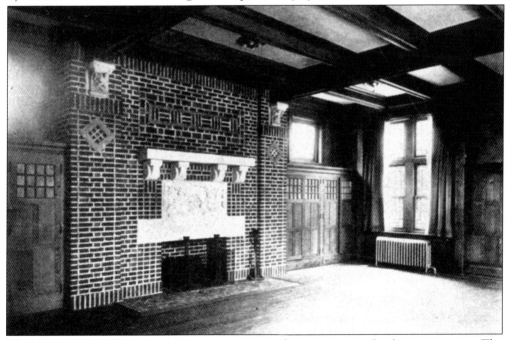

The Marvin Parish House contains a gymnasium and meeting rooms for the congregation. The arts and crafts interior is cozy and intimate, with coffered ceilings, clean lines, and a feeling of balance and symmetry.

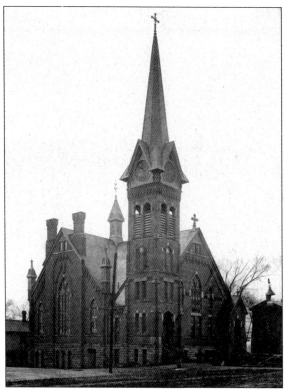

On April 27, 1857, the First German Reformed Church of Akron filed its articles of incorporation, and in 1858, it purchased the Baptist church. In the church tower was a 1,200-pound bell, originally paid for by the public and used as the town bell. In 1878, the church underwent a massive interior renovation, with walls and ceilings frescoed, a new pulpit, the gallery enlarged, and the seats freshly grained.

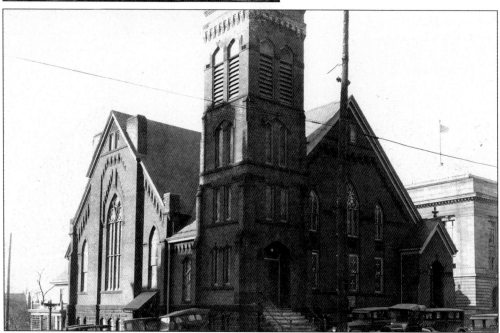

As the church continued to grow, in 1880, the congregation purchased seven acres of land on Aqueduct Street for use as a cemetery, naming it Mount Peace. In 1891, when a new brick church was built on the corner of South Broadway and East Center Streets, the bell was brought along and installed in the new tower. (Courtesy Akron Beacon Journal.)

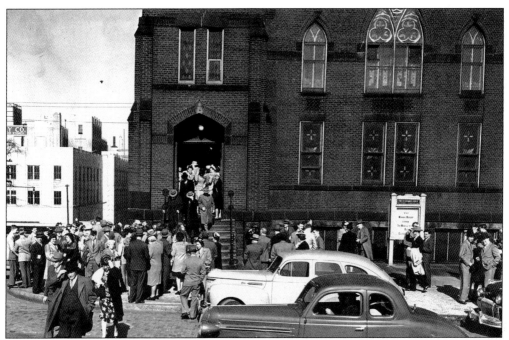

Built at a cost of $27,000, the new building was dedicated on May 3, 1891. In 1942, the German Reformed churches in the United States united with the Evangelical Synod of North America and officially became known as the Evangelical and Reformed Church. This photograph from 1947 is the old German Reformed church now merged with First Evangelical. (Courtesy Akron Beacon Journal.)

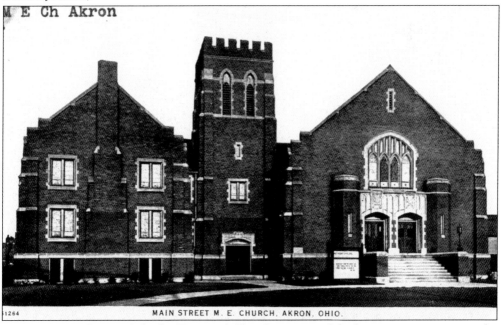

MAIN STREET M. E. CHURCH, AKRON, OHIO.

For years, Main Street Methodist Episcopal Church was one of the largest congregations in the city. This Gothic Revival church was built in 1928, undergoing a $40,000 renovation in the 1960s. Today the church is part of Open M, a neighborhood ministry.

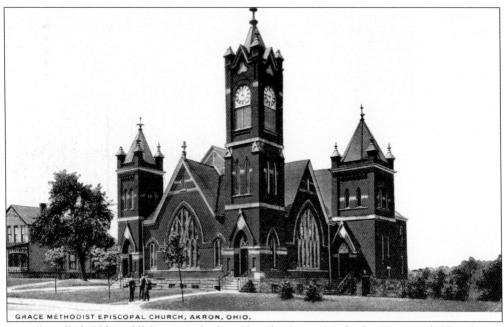

GRACE METHODIST EPISCOPAL CHURCH, AKRON, OHIO.

Initially called Old Middlebury Methodist Church, Grace Methodist Episcopal Church was originally a circuit church, sharing a pastor with churches in Tallmadge, Brimfield, Mogadore, and Pleasant Valley. In 1870, it became its own charge, and in 1878, the congregation built a church at the corner of Arlington and Exchange Streets. Later the building would be remodeled by the city's well-known architect Jacob Snyder, at a cost of $3,000.

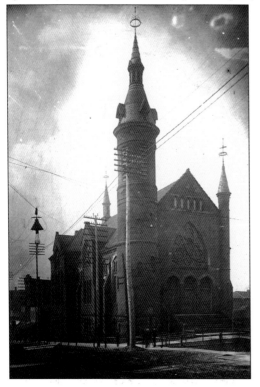

The Universalists were the first congregation to build a church outside the Gore, as most of its members were residents of North Akron and Middlebury. Dr. Eliakim Crosby donated a lot on North High Street for the church's first building; in 1891, the congregation built this church on the corner of Mill and Broadway Streets for a cost of $40,000.

Not really a church, since 1917 the gray terra-cotta-clad neoclassic Masonic temple has been a part of Akron's downtown. Long the domain of the Masons, only recently has the building been opened to the public. The interior is filled with details, including marble, elaborate friezes, terrazzo floors, and wood trim; the ladies' room features an Italian Renaissance fireplace.

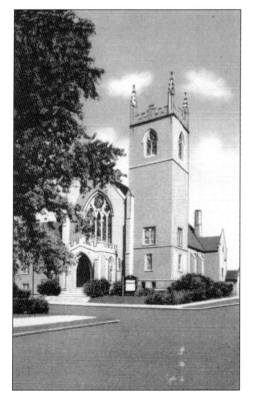

Located in Akron's Kenmore neighborhood, Goss Memorial Church first organized in 1904. The first building was a frame Presbyterian church located in Marshallville; it was purchased by a Dr. Goss, a Wadsworth pastor, for $600 only if the name Goss was used. It was moved to Akron on a huge platform on rollers, drawn by four large farm horses, taking one week. The church to the left had its cornerstone laid in 1928 and was completed in 1929.

On December 15, 1831, the First Presbyterian Church of Middlebury was founded with 26 charter members, including Harvey B. Spellman, father of Laura Spellman, wife of John D. Rockefeller. In 1884, the congregation built this, its second church, at North Arlington and Kent Streets, where it remained until 1904. (Courtesy Summit County Historical Society.)

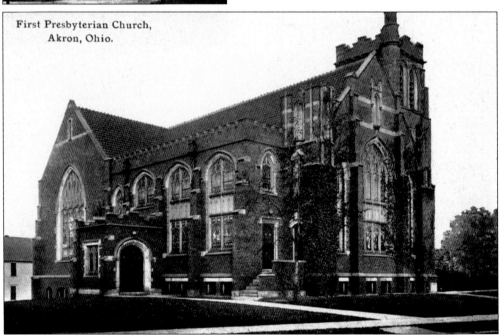

First Presbyterian Church, Akron, Ohio.

A new Gothic Revival church was built in 1904, and as described by the *Akron Press*, "The outside walls will be faced with iron clay brown brick and trimmings of buff stone. The interior wood work will be of cyprus [*sic*] and southern pine stained and varnished. The main auditorium will be 50 by 58 feet, with bowled floor, arched alcove for the choir and organ."

On May 14, 1905, the new church was dedicated. Before the Civil War, the issue of slavery divided the church. The pro-slavery advocates left to form their own church, called the "White Church," while the abolitionists remained. By 1859, however, the White Church returned and the "Union Church" was formed.

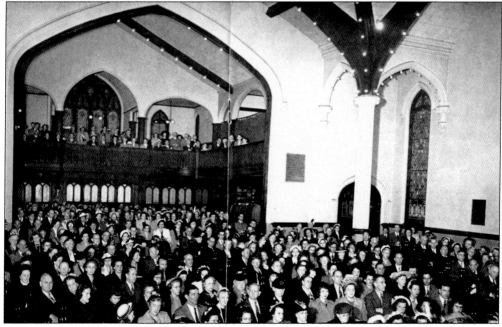

As seen in this photograph, the new church was originally built in the Akron Plan design. Sunday school classrooms line the back of the nave, separated by doors; modifications over the years have completely eliminated the plan layout. When it was built, the new church included both gas and electric lighting, with electric lights lining the arches as a decorative feature.

Over the years, First Presbyterian Church has seen many changes. In the 1950s, an educational wing with classrooms and offices was built, the dark wood in the church was replaced with a lighter wood, and the lights around the arches were removed. In 1985, the church spent $250,000 to renovate and remodel the sanctuary.

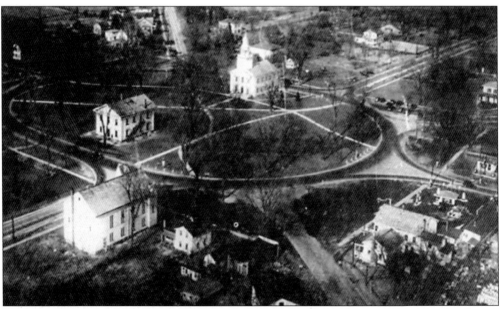

This aerial photograph from the 1930s shows the eight roads leading to Tallmadge Circle and the historic Tallmadge Congregational Church. Tallmadge was established through the efforts of Rev. David Bacon, who dreamed of establishing a community that would conform to his high religious ideals. (Courtesy Summit County Historical Society/Tallmadge Historical Society.)

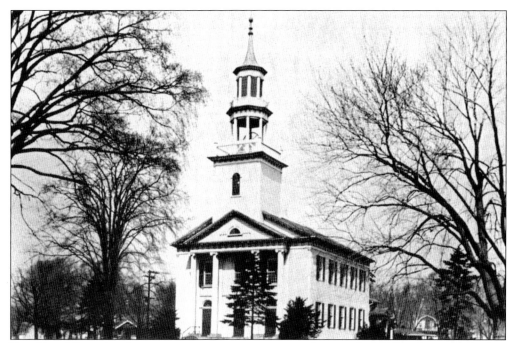

Rev. David Bacon's religious community never came to fruition, but Tallmadge continued to grow, and in 1819, a Tallmadge committee of seven men developed plans for building the church. On Monday, December 24, 1821, the members began to haul in the logs. The shingles were hewed from one chestnut tree and the side wood from a donated whitewood. The four large columns were made from solid walnut logs, shaped and reeded by hand.

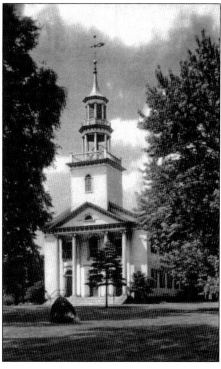

It took three years to build, but the church was finally completed and was dedicated on September 8, 1825. The wood, brace-framed church features a Greek Revival portico, supported by four large columns, and a dominant 100-foot-high steeple with a weather vane. The main building measured 44 feet wide by 56 feet long.

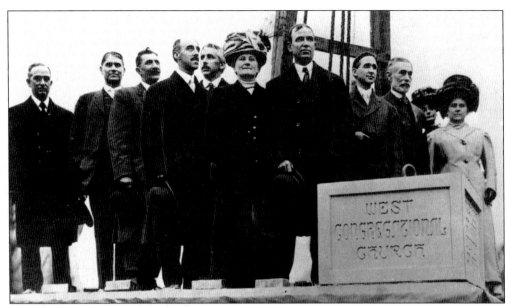

By 1885, many of the downtown churches' parishioners were coming from the West Hill neighborhood; many pastors were sent to the area to conduct additional services. Land for a new area church was donated by Lorenzo Hall, and under the sponsorship of First Congregational, West Evangelical Congregational Church, or more simply West Congregational, was established. (Courtesy Akron Beacon Journal.)

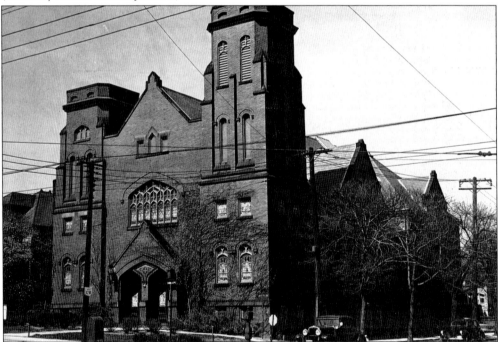

Located at the corner of West Market and North Balch Streets, the 50-foot-by-50-foot wood frame structure was completed in 1887 at a cost of $6,300. In 1909, the frame church was demolished, and a large tent was set up while the new building was constructed. The cornerstone for the new church was laid in 1910. (Courtesy Akron Beacon Journal.)

In 1963, the name of the church was changed to West United Church of Christ; by the 1960s, a changing neighborhood, new churches starting farther west in Akron, and an aging congregation signaled the end of West Congregational. Today the site is the location of the American Red Cross building.

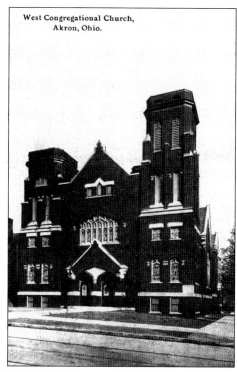

West Congregational Church, Akron, Ohio.

United Brethren Church was formed in 1882 with 12 members and one Sunday school student. In 1884, a 30-foot-by-45-foot church on the corner of Hill and James Streets was built for a total cost of $3,200, including both lot and building. During the 1890s, a new church was built on the corner of East Center Street and Buchtel Avenue at a cost of $18,000.

GLOSSARY

apse: The semicircular or polygonal section of the sanctuary. Generally used in Romanesque, Byzantine, and Gothic cathedral and church architecture.

barrel vault: The simplest form of a vault. Also known as a tunnel vault or a wagon vault, the barrel vault is essentially a continuous arched surface.

buttress: An architectural structure built against or projecting from a wall that serves to reinforce the wall. It provides support, acting against the lateral (sideways) forces from roof structures that lack adequate bracing.

chancel: The area of the church containing the altar.

cruciform: Churches with a floor plan in the shape of a cross.

flying buttress: A half or semi-arch of stone masonry, with the elevated end of the arch supporting the wall and the lower end of the arch mounted on foundations, or pillars, or other flying buttresses. It helps support the walls given the downward pressure of vaulted ceilings. Notre-Dame Cathedral in Paris is an outstanding example of a church largely supported by flying buttresses.

groin vault: A vault produced by the intersection at right angles of two barrel vaults. Also known as a double-barrel vault or cross vault.

narthex: The church entryway. Also called the vestibule or lobby.

nave: The main body of the church. The name is derived from the Latin word *navis*, or "ship," as the church was considered the ark, or ship, of the Lord.

rib vault: A vault in which the edges are outlined in stone.

transept: Generally found in a cruciform church. If the nave is the vertical portion of the cross, then the transepts form the horizontal line and reference the areas that lie beyond the nave. They usually extend out from the church in front of the chancel.

vault: A stone ceiling or roof.

BIBLIOGRAPHY

Britannica Concise Encyclopaedia. London: Encyclopaedia Britannica, 2006.

Carney, Jim. "Church of 1800s Washed Clean; St. Vincent's Exterior Beige Again after Grime Removed." *Akron Beacon Journal,* May 24, 1997, evening edition, sec. A10.

Chambers, Murphy & Burge, Restoration Architects. *Zion Lutheran Church: Preservation Master Plan.* Akron, OH: February 28, 2007.

The Concise Grove Dictionary of Art. Oxford: Oxford University Press, Inc., 2002.

Fletcher, Tom. "New York Architecture Images: Romanesque Revival/Queen Anne." http://www.nyc-architecture.com/STYLES/STY-Romanesque.htm.

Grismer, Karl. *Akron and Summit County.* Akron, OH: Summit County Historical Society, 1952.

Hannibal, Joseph. *Guide to Stones Used for Houses of Worship in Northeast Ohio.* Cleveland: Cleveland State University Center for Sacred Landmarks, 1999.

Lane, Samuel A. *Fifty Years and Over of Akron and Summit County.* Akron, OH: Beacon Job Department, 1892.

Norman, Edward. *The House of God: Church Architecture, Style and History.* London: Thames and Hudson, 1990.

Powers, Murray. *History of the Catholic Church in Summit County from Origin to '76.* Akron, OH: self-published, 1976.

Schaller, Lyle E. *The Church in Akron: An Interpetive [sic] Analysis.* Cleveland: Regional Church Planning Office, 1963.

ACROSS AMERICA, PEOPLE ARE DISCOVERING SOMETHING WONDERFUL. THEIR HERITAGE.

Arcadia Publishing is the leading local history publisher in the United States. With more than 3,000 titles in print and hundreds of new titles released every year, Arcadia has extensive specialized experience chronicling the history of communities and celebrating America's hidden stories, bringing to life the people, places, and events from the past. To discover the history of other communities across the nation, please visit:

www.arcadiapublishing.com

Customized search tools allow you to find regional history books about the town where you grew up, the cities where your friends and family live, the town where your parents met, or even that retirement spot you've been dreaming about.